Excellence in Reborn Artistry™

Where each and every Baby is a "One of A Kind" Original

Coloring Techniques using Genesis Heat Set Paints

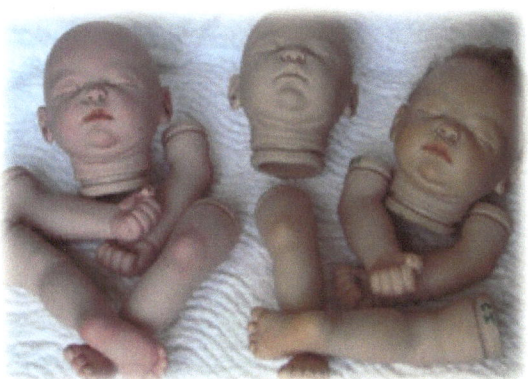
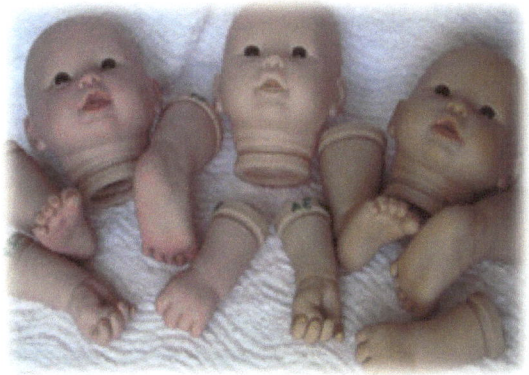

Part 2 – Newborn Layering Techniques

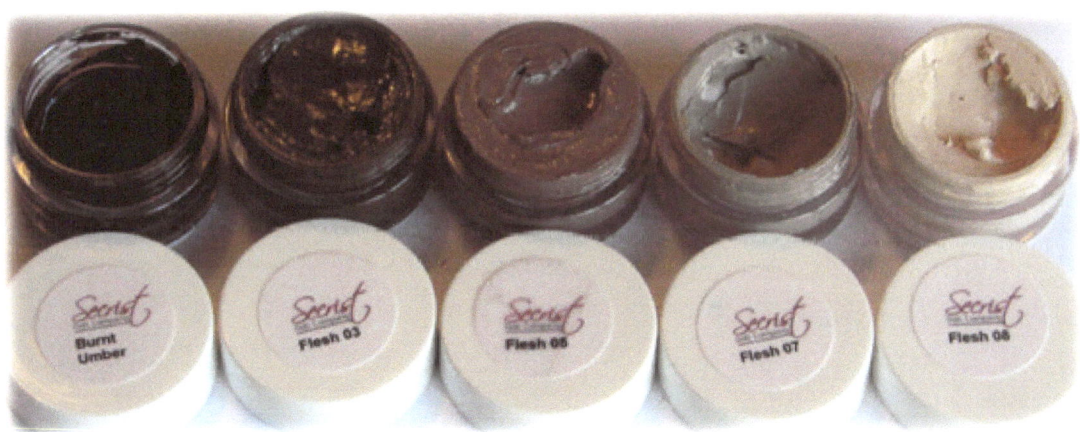

Jeannine Marie Holper

255
Elizabeth Catherine

www.RebornArtistry.com

The author and publisher have taken care in the preparation of this book, but make no expressed or implied warranty of any kind and assume no responsibility for errors or omissions. No liability is assumed for incidental or consequential damages in connection with or arising out of the use of the information or instructions contained herein.

Document Version 2007 – August-December

Copyright © 2007 Jeannine M. Holper

All rights reserved. No part of this publication may be reproduced, stored in a retrieval system, or transmitted in any form, or by any means, electronic, mechanical, photocopying, recording or otherwise, without the prior consent of the publisher and author. Published and / or Printed in the United States of America.

ISBN 978-0-6151-8074-8

Released January 2008

CONTENTS

- **Introduction**
- **Supplies**
 - Newborn Kits & Reborn Doll Kits Basic Supplies
 - External Base Skin Tones
 - Mixing & Measuring Charts
- **Base Skin Tones**
 - Techniques for Light to Medium & Darker Complexions
 - 19 inch Ming - Asian / light skin tones
 - 17 inch Zoe - Caucasian / light skin tones
 - 19 inch Starling - African American skin tones
 - Using the Color Wheel for Corrections
- **Newborn Layering Complexion Techniques**
 - The 6 Step Layering Technique Basics
 - with Genesis Heat Set Paints
- **Finishing Touches**
 - **Accents & Body Art…**
 - Body Art for Eyes, Lashes and Brows, Accents for Lips
 - Body Accents for Creases and Wrinkles
 - Baby's Manicure, Body Art for Skin Variations
 - **Finishing Touches…**
 - Satin Sealants / UV Protection
 - Baby Tears, Moistening, Life-like

Included throughout: Tips & Techniques

Secrist Doll Company is a manufacturer and provider of Reborn art supplies for Reborn artists and hobbyists. The painting supplies and dolls kits featured in this book have been obtained from the Secrist Doll Company. Although supplies, materials and doll kits may change from year to year, you can find their current line of products at www.Secristdolls.com.

Excellence in Reborn Artistry™

You, too, can transform a baby doll into a "Precious, True To Life Artist Baby"
Where each and every Baby is a
"One of A Kind" Original

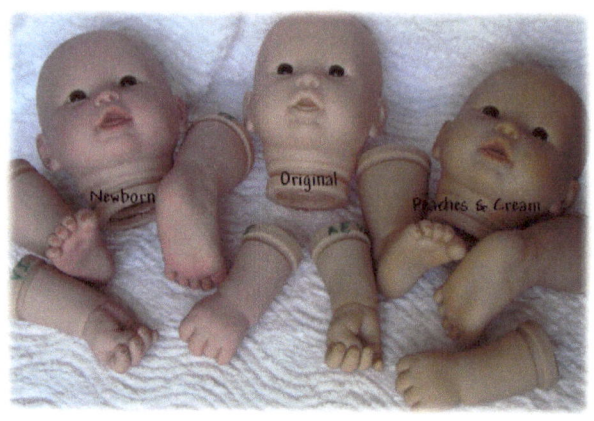

Thank you for taking the time to read this instructions book to *Learn the Art: Coloring Techniques using Genesis Heat Set Paints GHSP.* This is Part 2 of a Two part set in the Excellence in Reborn Artistry™ series of books to look into more details and specifics of the Reborn & Newborn Artistry techniques to create Collectible & Heirloom "One of a Kind" Dolls.

This **Learn To Paint** – Part 2 book will provide you a step by step process of transforming a Secrist™ Vinyl Doll Kit into a cherished collector doll. We will be using the Secrist™ Doll Kits for our samples: 19 inch Ming

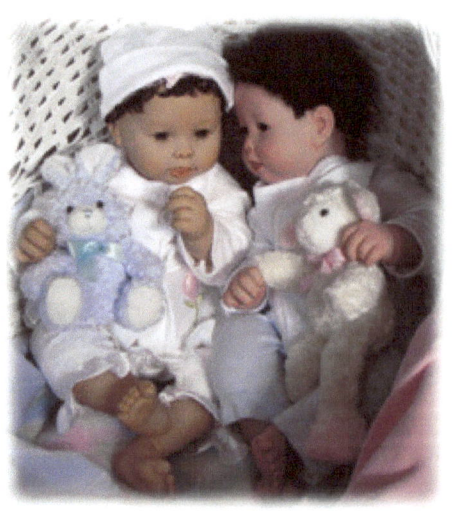

(Ming) for our Asian reborns, 17 inch Zoe (Allison) for our Caucasian reborns, and 19 inch Starling(Ty) for our African American reborn. Three doll sculpts will be done in the 6 Step Newborn Layering Technique.

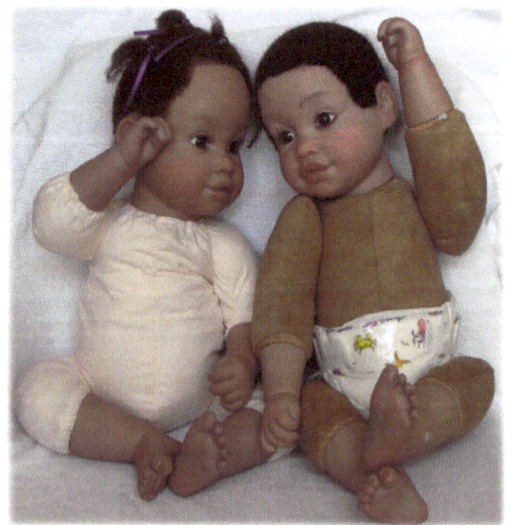

PatternsByJeannine™ Soft Body Patterns will be shown in addition to the

Secrist Doll Kit bodies which come in their kits; so that you can see several samples of cuddly collectible newborn dolls.

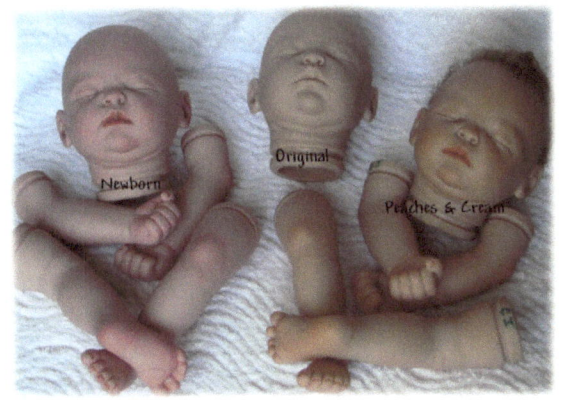

This instructions book will concentrate on the following Doll Kit areas: **External Base Skin Tone Techniques** for your kits; The **6 Step Newborn Skin tone Layering technique** using Genesis Heat Set Paints and one sample using Acrylics; In our **Finishing Touches** section we include Body Accents, Facial Accents (glistening eyes, lashes, & brows), veining and skin mottling samples, manicure options, & fun baby tears.

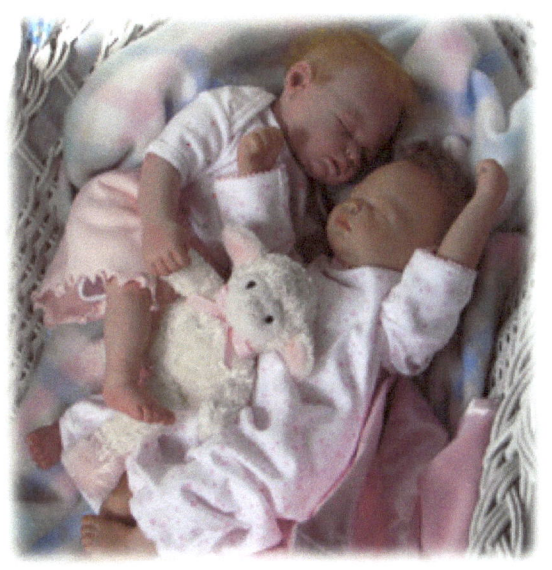

This book for Doll Kits will provide the basics and advanced techniques for many subject areas; However for additional studies and content, we recommend that you also might consider the following books for more details on specific topics:

Excellence in Reborn Artistry™ series of books:

 Learn To Paint using Genesis Heat Set Paints: Peaches and Creams Complexion
 Case Study #6 Realistic Hair Rooting Techniques
 Case Study #10: More on Mottling Techniques; Create your own OOAK mottling tools.

Please note: The statements above are generalized reborn artistry techniques to give you a feel for the efforts of the artist, and may not be included in each and every baby.

Reborn at your own risk. Each doll is different and these are just techniques, hints and suggestions, based on experience of the writer. We provide no warrantees or guarantees in your reborn activities.

Excellence in Reborn Artistry™
The Learn to Paint Series has three (3) books to choose from…

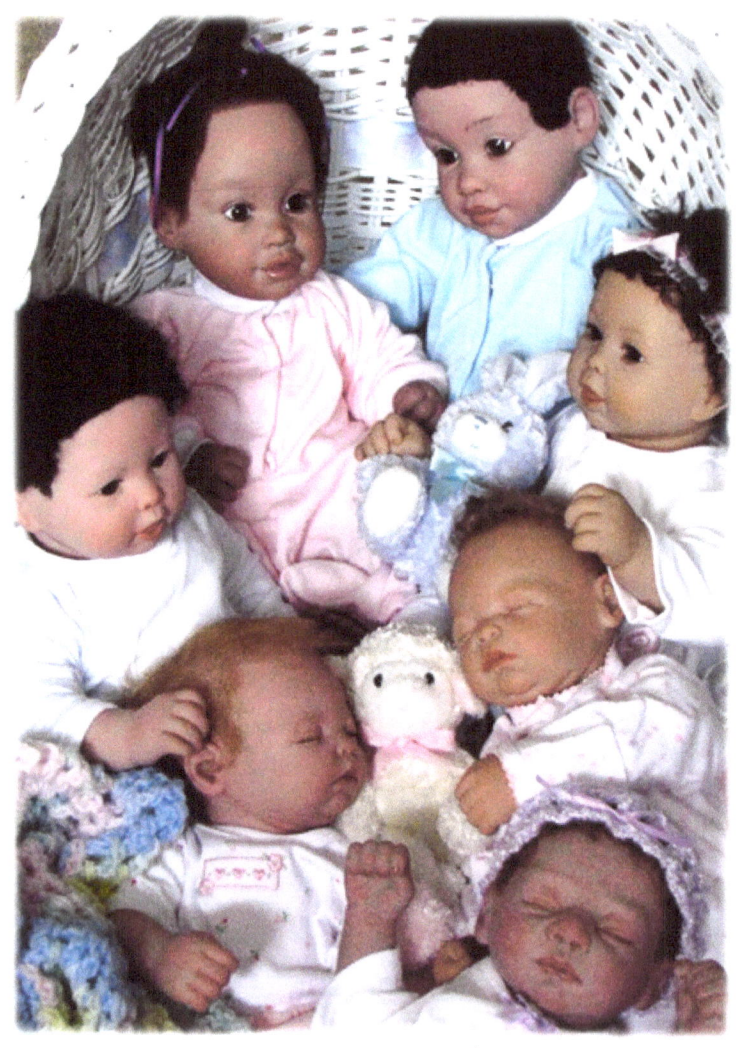

Excellence in Reborn Artistry™ Learn to Paint Part 1: Peaches and Creams
Features Myesha(Starling), Minueta(Ming), and Alyssa(Zoe)

Excellence in Reborn Artistry™ Learn to Paint Part 2: Newborn Skin Layering
Features Ty(Starling), Ming, and Allison(Zoe)

Excellence in Reborn Artistry™ Learn to Paint Master Collection
a.k.a. Collector's Edition at 120 pages & 300 pictures
Features Starling (Myesha & Ty), Ming (Minueta & Ming) Zoe (Alyssa & Allison), with a special guest star appearance by Taffy

Reborn Artists Supplies

Basic Supplies: Newborn & Reborn Artistry Tasks

Paint brushes. These brushes were hand-picked for use in reborning & newborning dolls. As a reborn artist and instructor, I have found them very useful and they will be a great asset in your art work. As you go through this book we will remind you of the uses for many of these brushes to make your beautiful reborn baby dolls. Get these from secristdolls.com.

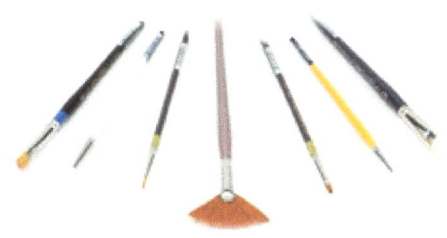

Make-up Sponges. Cosmetic foam wedges are wonderful for layering the base color of paints. These basic sponges can be used as a tool to apply your paints to the faces of your babies. With these smaller sponges you will be able to control the blushing on the cheeks, apply the overall skin pigmentation on the initial layer(s) and even more.

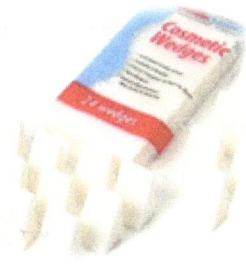

Disclaimer: This information is not an endorsement for any one particular tool or product. It only gives you options and processes that have been successful for many reborn artists. Please respect your tools and use them for Newborn & Reborn Artistry at your own risk.

Cotton tipped applicators. In the art of reborning another great product is the cotton tipped swap applicators. They provide a basic application and touchup tool for the artist of all abilities. These applicators allow you access to small areas, as well as provide you a tool for clean up and touch up when paint gets into delicate hard-to-reach areas. The ball works well for clean up on larger areas while the point allows you to get into crevices and other tight places.

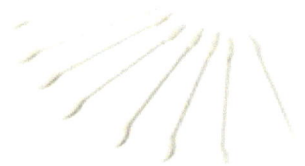

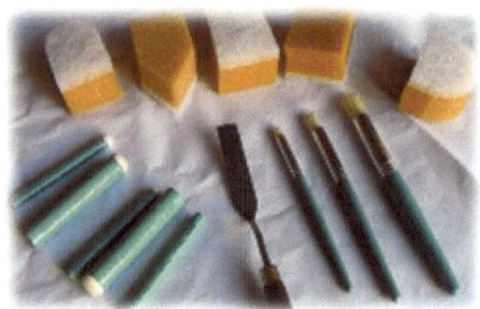

Stencil Brushes. I love the hardness of the stencil brush. I use them a lot for grabbing paint colors and mixing them together with thinner. They are also great for dry placing colors into crevices or smoothing out colors already within crevices.

Vinyl Sealants & UV Protectors. When there is a need to protect, use Genesis Heat Set Matte Varnish as your sealant. Please apply sparingly over two coats, as it is much better than one thick coat.

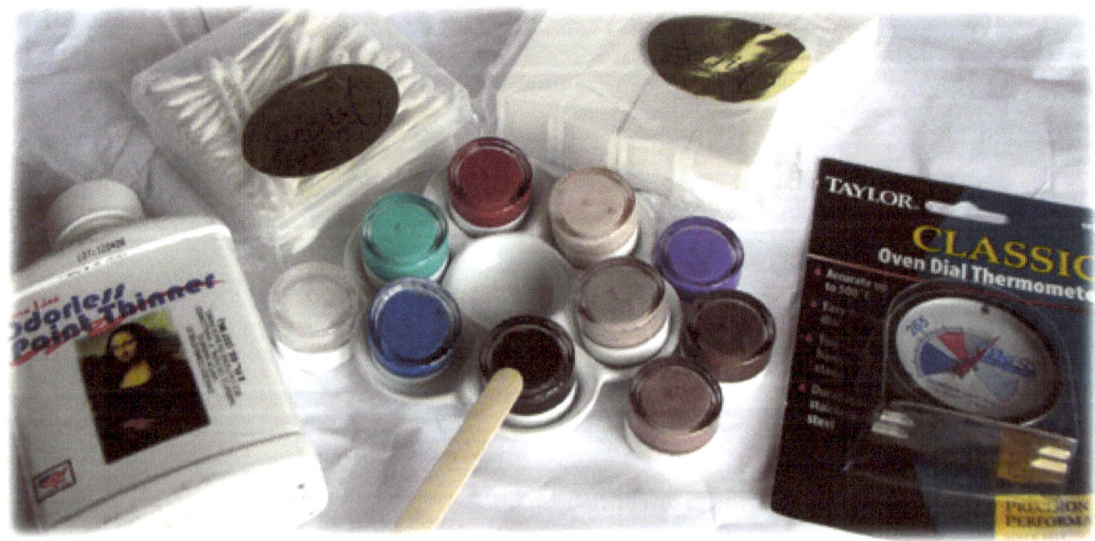

You can obtain the **Genesis Paints Basic Paint Set** from www.secristdolls.com which comes with 9 different colors and a bottle of Odorless Thinner (100% Mineral spirits base). Here are our basic recommended colors to include…

1) Titanium White
2) Yellow
3) Flesh 04
4) Flesh 07, Flesh 08
5) Pyrrole Red, Crimson
6) Phthalo Blue, Ultramarine
7) Phthalo Green
8) Matte Finish

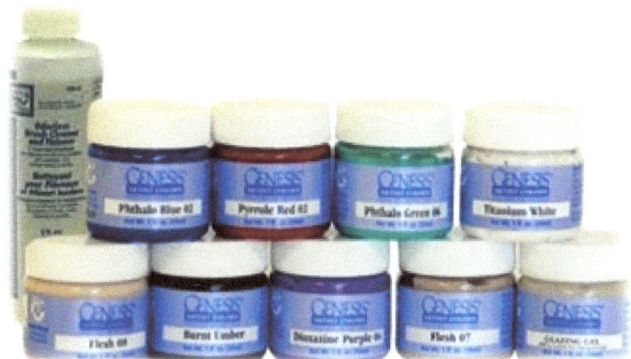

Mixing Trays. When mixing Genesis paints we recommend that artists avoid using plastic palettes. The strong bonding qualities of Genesis paints can react with certain plastic palettes and ruin the paint! These porcelain palettes have a kiln fired gloss coating that will last a life time and never wear out or react with your doll making paints. They are also very easy to clean after use. Larger porcelain containers for mixing can be picked up at kitchen accessory stores.

Pre-Mixed Colors. If you have experienced the blush being too red or the baby looking like she has lipstick on! Secristdolls.com makes life easier with pre-mixed paints that are just the right color.

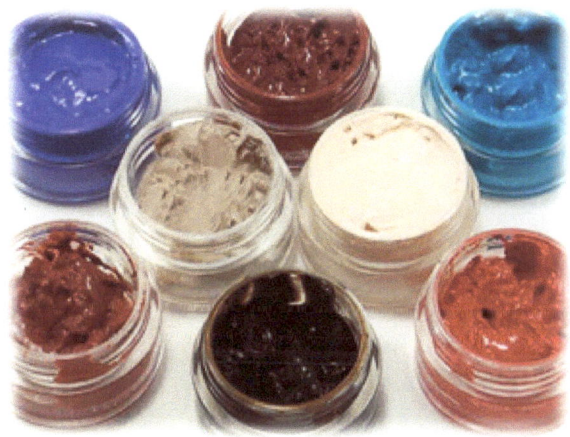

This set of paints is enough for 8 to 10 dolls depending on artist's usage and application. Except for Flesh 08, Periwinkle Blue and Blush, all other colors are used in such small quantities that the petite amount will easily last for as many as 30 dolls when used as suggested. The Pre-Mixed Paint Set (each jar is labeled) includes:

Eyebrow Brown Paint, Periwinkle Blue Internal Wash Paint, Crease & Wrinkle Paint, Blush Paint, Lip Paint, Vein Paint, Flesh 07, & Flesh 08

Cure / Bake / Dry Time for Genesis Heat Set Paints. Between each layer of Gensis paints, you need to cure (or dry) your paint layer. To do this you can use your oven or Genesis Heat Set Gun. When using the oven, set to 265 degrees F, or 130 degrees C. Time the paint to dry in the over for at least 8 minutes, as the paint needs to reach this temperature in order to be permanently set. Then remove and allow your parts to cool to room temperature. Temperatures can affect the depth of the staining process; use caution as there are no guarantees.

OOAK Mottling Sponges for application of the newborn layering techniques. Makeup sponges, household sponges, craft sponges, sea sponges & more. All are great application tools for your painting mediums.

Paper Toweling & Sponges. For spills and quick wipe removal. A plastic picnic table cloth works well to protect your working area surface.

Color Wheels. Looking at the color wheels gives you a great opportunity to understand how the mixing of the primary colors creates new colors. It also provides an opportunity to look and see how might someone correct a color that has been created and make it better. Review the color wheels when you get to that section of the book on correcting colors.

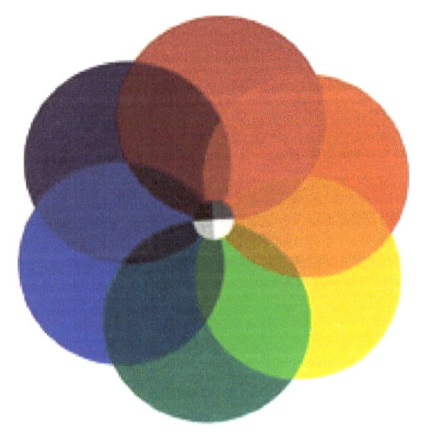

For more color wheel samples, just search the internet for COLOR WHEELS.

Base Skin Tones for Vinyl Dolls

There is nothing that states you must change the skin tone of your vinyl kit. If you like the base color, then go ahead and start with your Peaches and Cream or Newborn Layering techniques. However, if you want or need the ability to change the vinyl color to a more realistic skin tone, here are a few of the methods used by reborn artists.

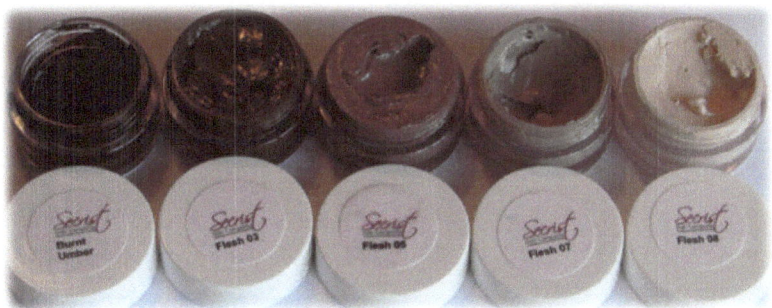

External Color Application Method

You can create all skin tones with some sort of external painting technique. When you are painting externally, you don't have to worry about cutting open the limb openings, as you won't need to paint inside.

Wash the outside of the vinyl with very warm soapy water and let dry completely. Once dry, wipe the outside vinyl parts with rubbing alcohol so that your painting medium will adhere to it the best it can.

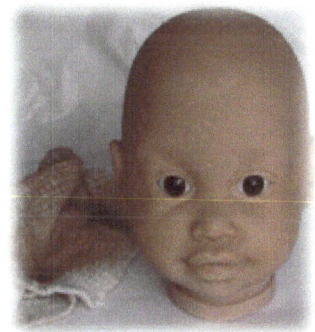

When coloring, what you are trying to achieve is to transform your vinyl's original color to a living flesh tone color for the ethnicity of your choice.

If you are doing the Newborn Layering Techniques, many artists will start directly with the layering colors within the 6 steps (you will get more details on this in that section of the book).

For Medium and Darker complexions, you normally would paint with thinned out colors of medium to darker skin tones, flesh tones, brown/reds or brown colors.

Corrections to Skin Base using the Color Wheel Chart

If you want to correct/or eliminate a hue of color, you can use the color wheel chart.

Select the opposite color in the color wheel, to determine which color shade to use to help tone out the color from being visible.

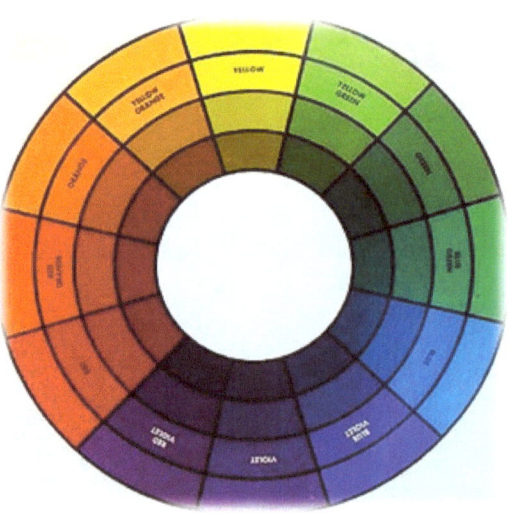

Here are some recommended colors for various complexions.

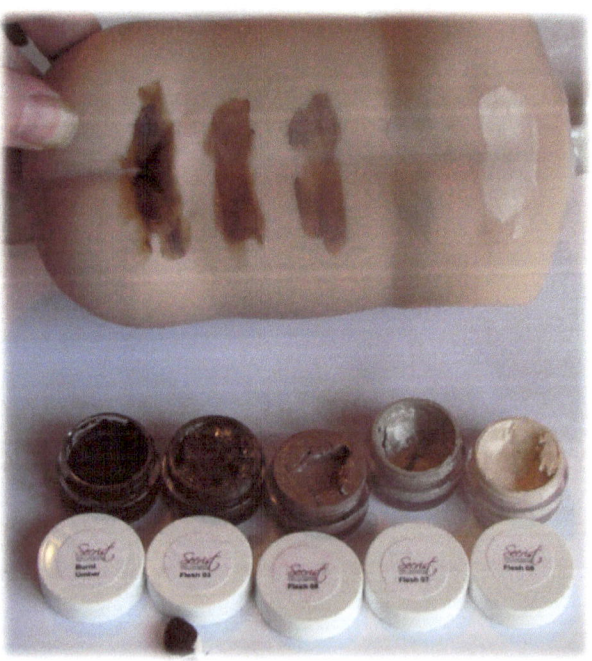

Light Complexion

Genesis Heat Set Paints. Flesh 08 to 07 works well for creating various skin tones for light to medium based dolls. Mix with your thinner of Mineral Spirits (6 to 8 parts thinner to 1 part color) to create a very transparent base color. For deeper tones, you may want to mix with less thinner; for lighter tones mix with more thinner.

Figure: Colors shown are applied directly to vinyl with no thinner.

Light to Medium Asian Complexion

Genesis Heat Set Paints. Flesh 07 to 08 works well with a hint of yellow for creating various skin tones for light to medium based dolls with an Asian hue. Mix with your thinner of Mineral Spirits (6 to 8 parts thinner to 1 part color) to create a very transparent base color.

Light to Medium Reddish Complexion

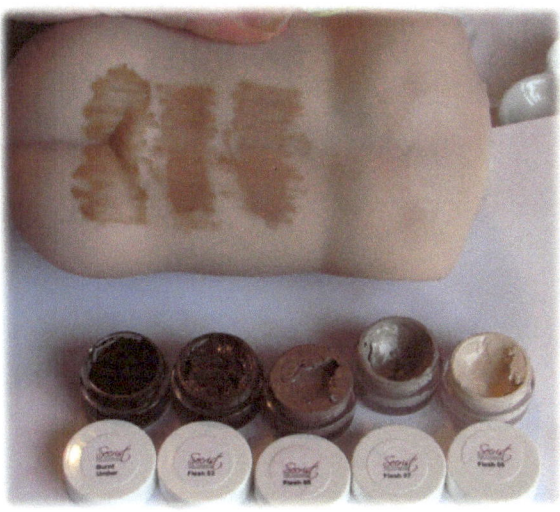

Genesis Heat Set Paints. Flesh 06 to 08 works well with a hint of Burnt Umber or Red for creating various skin tones for medium based dolls with a reddish hue. You can use one, both or all three colors to create the look that you want. Mix with your thinner of Mineral Spirits (6 to 8 parts thinner to 1 part color) to create a very transparent base color. For deeper tones, mix with less thinner; for lighter tones mix with more thinner.

Figure: Colors shown as whisked back and forth with a Q-tip applicator.

Medium Complexion

Genesis Heat Set Paints. Flesh 05 to 03 works well for creating various skin tones for medium based Hispanic, African American, and Indian dolls. You can use one, both or all three colors to create the look that you want. Mix with your thinner of Mineral Spirits (6 to 8 parts thinner to 1 part color) to create a very transparent base color. For deeper tones, mix with less thinner; for lighter tones mix with more thinner.

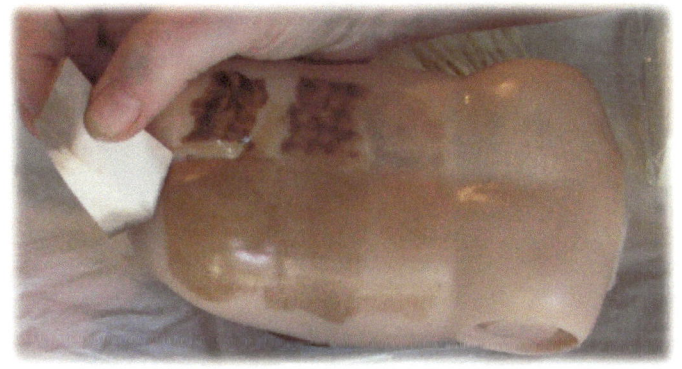

Figure: Colors shown blotted with Mineral Spirit Thinner on a makeup pad and "pounce" on the lower half of the vinyl.

Medium to Dark Complexion

Genesis Paints. Flesh 03, and Burnt Umber are perfect for creating various skin tones for darker skinned babies like Hispanic, African American, and Indian. You can use one, both or all three colors to create the look that you want. Mix with your thinner of Mineral Spirits (4 to 6 parts thinner to 1 part color) to create a transparent base color. For deeper tones, mix less thinner.

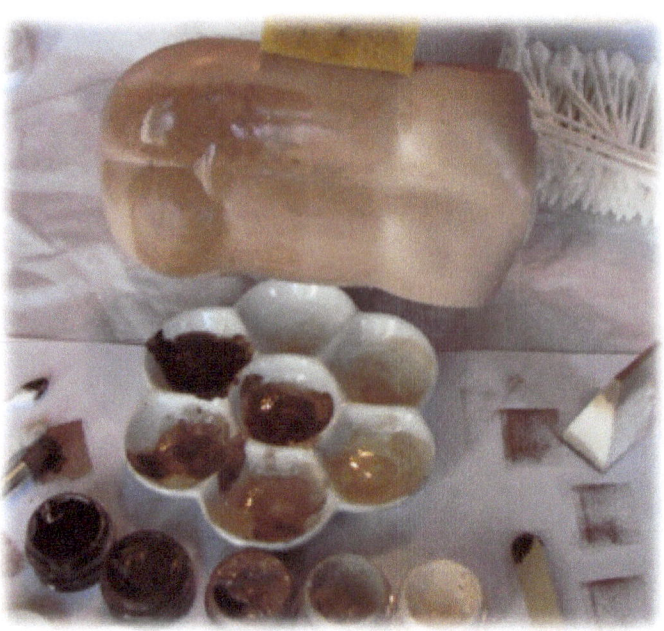

Figure: Colors shown blotted with Mineral Spirit Thinner on a larger sponge and "pounce" on the upper part half of the vinyl.

You have two options for curing your parts. Either by baking in an oven or by Heat Set Gun (see the curing section for more details). When baking, it is best to use a cloth on a cookie sheet to help protect the colors and vinyl while in the oven's heat.

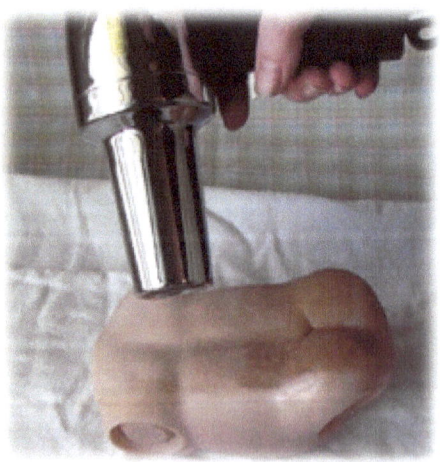 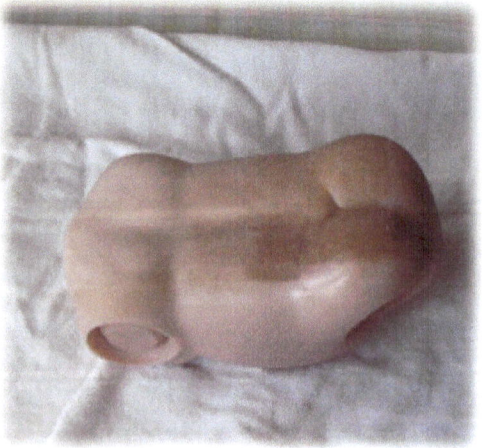

Paint Application Blending Technique. When applying genesis heat set paints to create a base skin layer, I like to use a blending technique. It does not matter which painting medium you use in this step, as long as you always blend it into/onto the vinyl.

Using your fan brush, painting brush sponge, or any other applicator, just paint or apply your desired <u>thinned out</u> color all over the vinyl. Then use a blending cloth (which is any soft cloth available) to rub the color into your vinyl so that it is smooth and blended evenly all over the exterior portions of the doll parts.

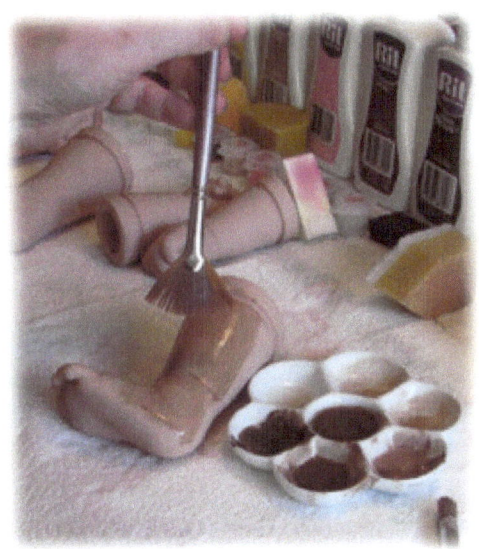

If you are a novice or using a color or painting application medium for the first time, you might want to test your efforts first on a piece of practice vinyl. Vinyl will absorb the colors over time, and it may also change slightly in sunlight. Silicon vinyl may react differently to colors than vinyl, so remember as you move from one type of doll to another, the colors may react differently.

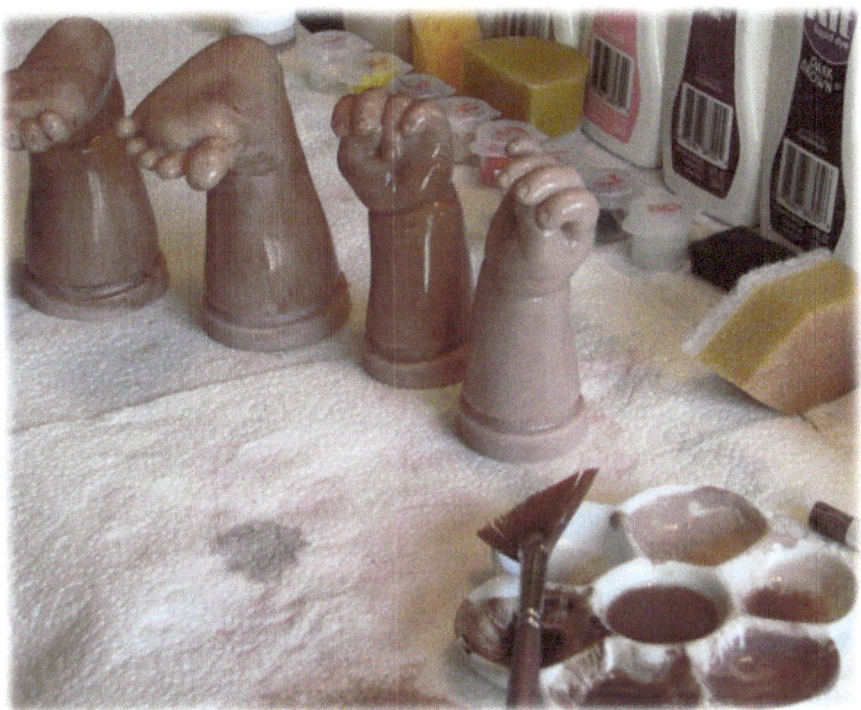

In the picture at left, I have applied a layer of our main skin tone colors on each limb. At the far left, it is burnt umber, then Flesh 03, then Flesh 05 and finally a mix of equal Flesh 07 and 08. Using the Fan brush, I have applied the paint and I allow it to sit on the vinyl for 15 minutes.

Then I take my blending cloth (as shown at right) and rub the paint into the vinyl, almost like a stain. Once blended in, I will set the piece on the cloth lined cookie sheet and accomplish a cure session in the oven. (see curing section for more details). As an alternative to using the blending cloth, you can take a clean makeup sponge, and blot the colors onto the vinyl until the colors are uniform in base layer.

Following the blending step, it is time again for the paint to cure (or "heat set" in the case of Genesis Heat Set Paints). However, this is the same for all paint mediums and blending techniques.

Both with Peaches and Creams application techniques and with the 6 layer newborn skin tone application technique - cure time (ie. A "heat set" session) is always important.

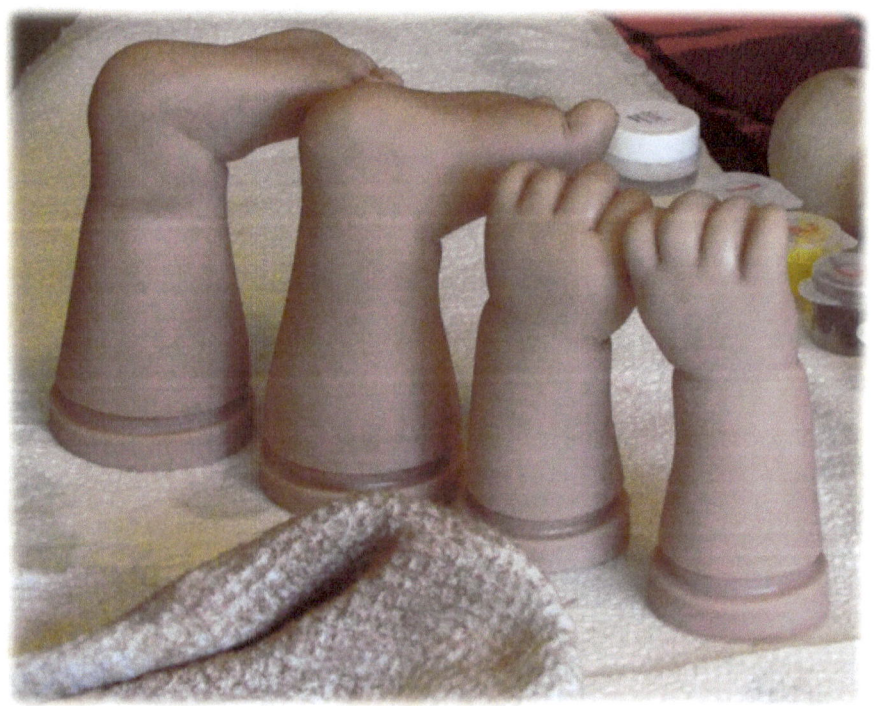

Above here are shown the four limb colors fully heat set and cured.

At the far left is burnt umber, then Flesh 03, then Flesh 05 and finally a mix of equal Flesh 07 and 08.

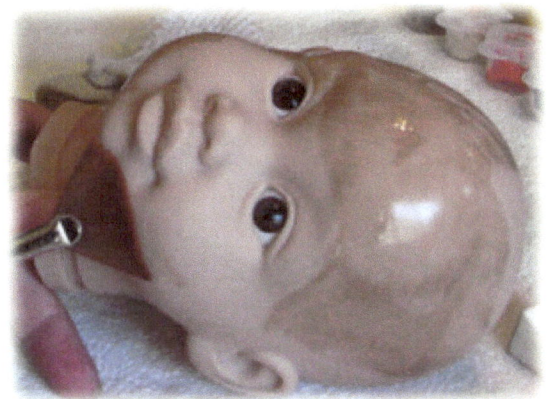

Shown at left, I've created a mixture of Flesh 03 and Flesh 05 and then started to apply the paint to Starling's head using the Fan brush. Then below here is shown the head fully covered.

Let's allow the paint to set for 12 hours overnight. Then in the morning I will blend in the colors onto the vinyl. This is done to show another alternative in the blending process, as we will have allowed the pigments of the genesis paint to seep into the vinyl over an extended period of time.

In the morning I used use the blending cloth, as shown below, to remove any extra/residual coloring prior to our head "heat set" baking session.

It will be more difficult to remove

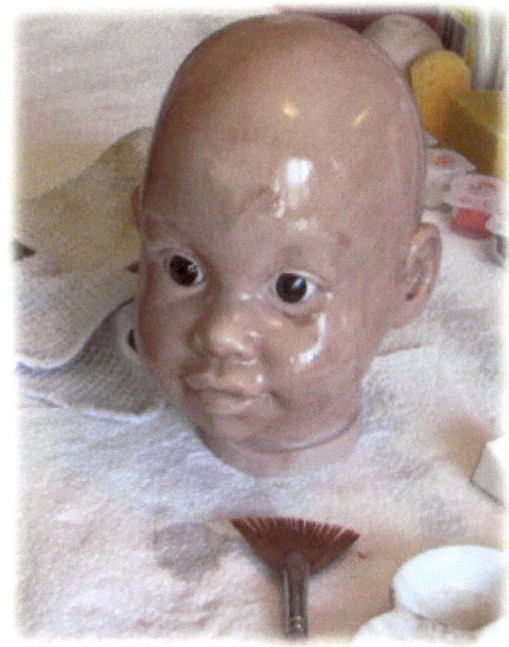

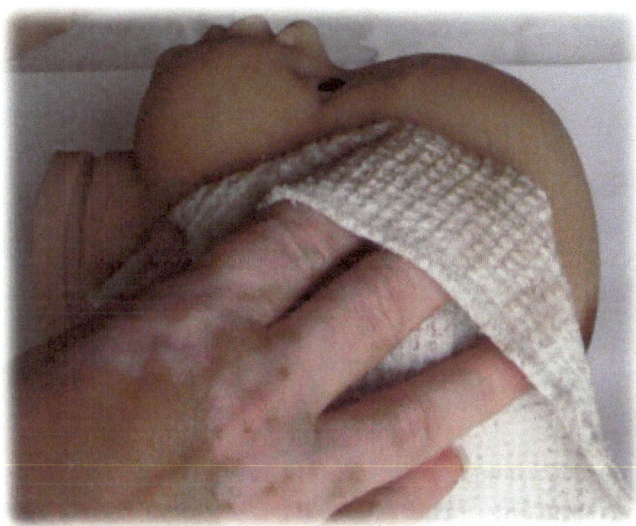

the excess in the morning, as the mineral spirits which were used as a thinning medium will have evaporated. So if necessary, you can add in a little bit of the mineral spirits to help you out with the blending process without disrupting the vinyl stained overnight.

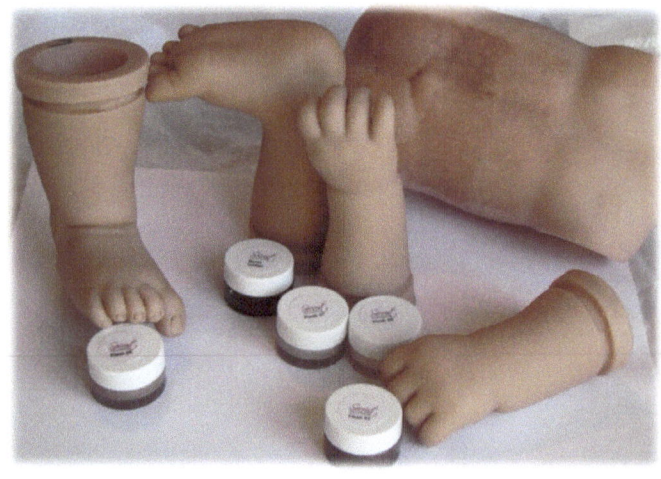

Figure: In the sample at left, I've placed the lighter Flesh 07 / 08 next to the Burnt Umber to show the contrast in coloring from the light tones to the dark tones. The back plate is shown to see the variations of the larger sponge, versus the makeup pad versus the blending cloth.

If, when you have "heat set" the paint, you decide you want it to be a bit darker, you just need to do another layer of blending and heat setting.

Each layer will add to the depth and richness of the color. But please remember babies are much lighter when born, even babies of color, so if you are looking for a realistic reborn, then please remember this note.

Paint Mediums & Cure Time

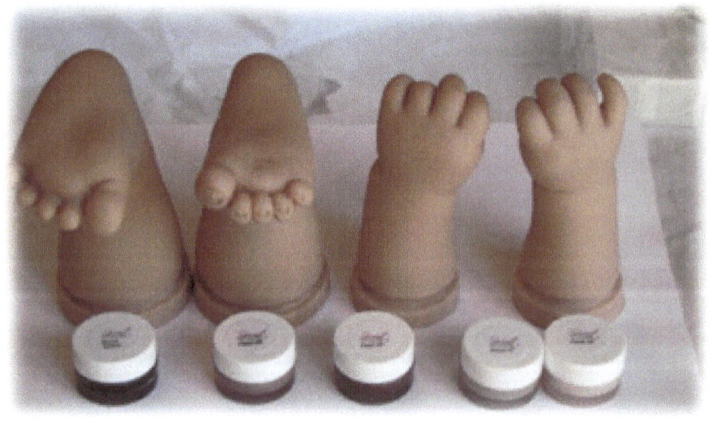

We have tested the Secrist Doll Kits and they worked very well in the oven, but watch out if you are using other soft vinyl doll kits; if a vinyl kit is too thin, you may have undesirable results (which has happened to some silicone and/or silicone vinyl dolls). If you end up with a shining baby after you have heat set, then use baby powder to help remove the shine (and it makes the doll smell good too).

CAUTIONS. It is not advisable to heat up hair, wigs or eyes (as it may affect the glues and adhesives). If you have your hair rooted in, you should protect it with a damp cloth wrapped around the hair (but not touching the paints). Make sure that no cloth touches any heating elements.

Excellence in Reborn Artistry™

Section 2

Layering Techniques for Reborns Using Genesis Heat Set Paints

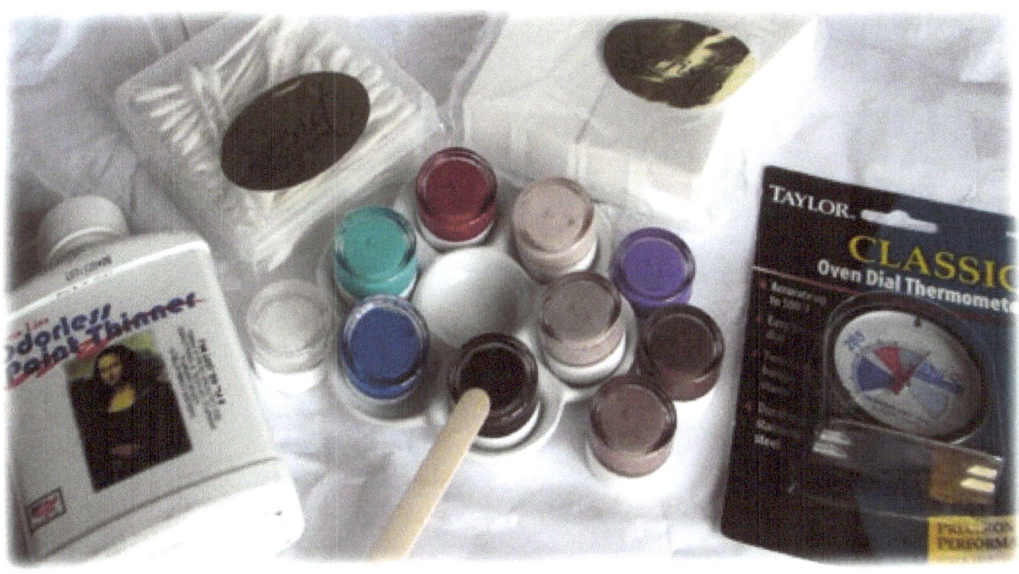

The 6 step layering technique can be used with almost any coloring medium. We will apply the layers together to form the basis for our reborn's realistic skin tone. Each artist has their own beautiful shades that they blend to create true-to-life reborns with realistic skin tone. Once you have tried this a few times, you may want to alter the suggestion colors within this book to create your own personalized color palette.

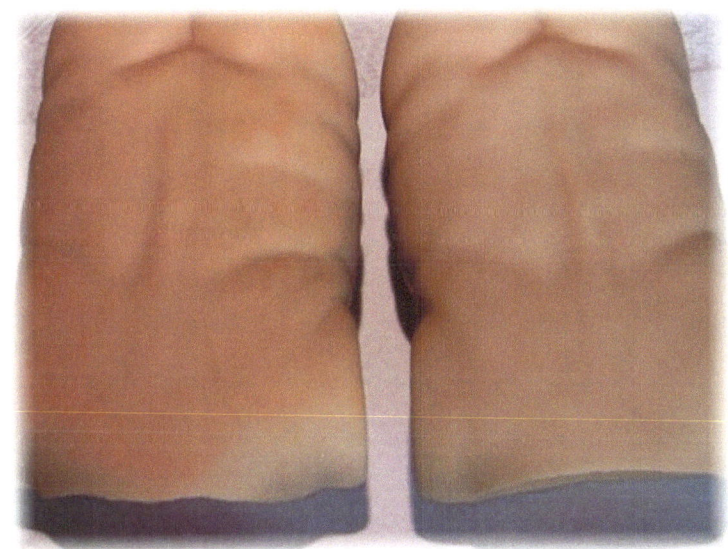

Using the basic colors of white, flesh, yellow, brown, burgundy/rose and red, will allow you to create many skin layers that will create depth and variations for your baby's precious skin.

Flesh 02	Quinacridone Crimson 01	Yellow Ochre
Flesh 03	Quinacridone Magenta 02	Yellow White 08
Flesh 04	Raw Sienna	Pyrrole Red 02
Flesh 05	Raw Umber	Phthalo Green
Flesh 06	Ultramarine Blue	Phthalo Blue
Flesh 07	Viridian Blue 01	Burnt Sienna
Flesh 08	White (Titanium)	Burnt Umber

Newborn Layering Techniques Color Chart

Layers	1st	2nd	3rd	4th	5th	6th
African American	White/Flesh06	Yellow	Flesh05	Flesh03	Burdt Amber	Red
American Indian	White/Flesh07	Yellow	Flesh06	Flesh05	Magenta	Red
Asia-Pacific	White/Flesh08	Yellow	Flesh 08	Flesh06	Yellow Ochre	Red
Caucasian	White/Flesh07	Yellow	Flesh06	Burnt Sienna	Crimson 01	Red
Hispanic	White/Flesh06	Yellow	Flesh06	Flesh05	Burnt Sienna	Red

I've provided the basic colors chart for various skin variations, but it is up to you to find the final blend that becomes your artistic signature. Don't worry if the color you have chosen is a slightly different color or shade than the ones in this book, as any of the basic colors will provide you an amazing reborn with realistic looking skin tones.

Base Layer

To create our base layer we will take a dab of Titanium White and Flesh 06 or 08 or Flesh color of your choice and place it in your tray. Place in 3 times more white than flesh color when selecting your color amounts.

Mix the colors and add thinning medium with your brush to the color until you can see through to the plate underneath the paint (← see picture at left).

Apply the colors to the vinyl with your makeup pad or brush. Blend over the body for a very thin layer (almost to the point of not seeing any paint).

If you have any excess paint in any single area, blot it off with a sheet of paper toweling by placing your hand gently, but firmly over the vinyl piece. Accomplish a "Heat Set" session now.

The final outcome should be barely noticeable to the naked eye.

Tonal Layer

To create our tonal layer we will take a dab of the yellow and add it in your color tray. If you want to prevent getting too much on the tray, then add it on the side area and dip your brush to bring over the amount you wish to add.

Mix the colors and apply more thinning medium with your brush until you can see through to the plate underneath the paint (very important step).

Using your selected sponge (which has been dampened by your thinning medium), dab into the paint mixture, and remove excess paint by blotting it on your paper towel. →

If you see it applies too thickly, then re-dab into your thinning medium remove excess, and re-dab over your vinyl body part(s) to thin out the excess paint mixture.

After the initial application of the tonal layer, followed by thinning and sponging, it will look something like this. →

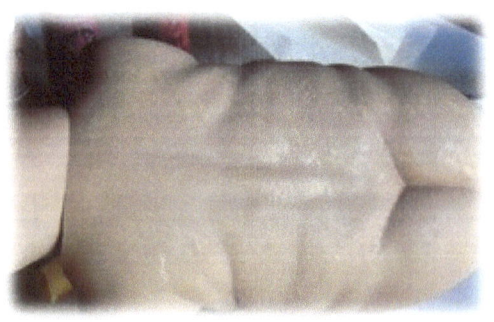

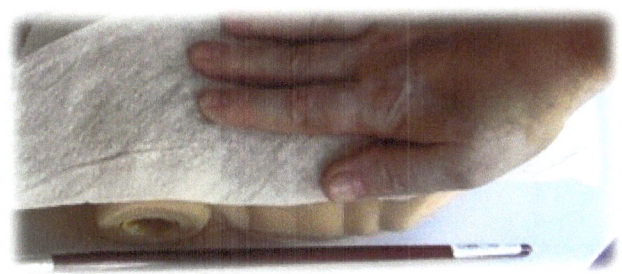

If overly wet, or if you have any excess paint or thinner in any area, blot it off with a sheet of paper toweling by placing your hand gently, but firmly over the vinyl piece.

Following your "heat set" session, the outcome of this layer will be somewhat more noticeable than the initial base-layer, but showing a hint of the whitish/yellow tint. You will even use this layer for African American skin tones and Asian and Hispanic skin tones.

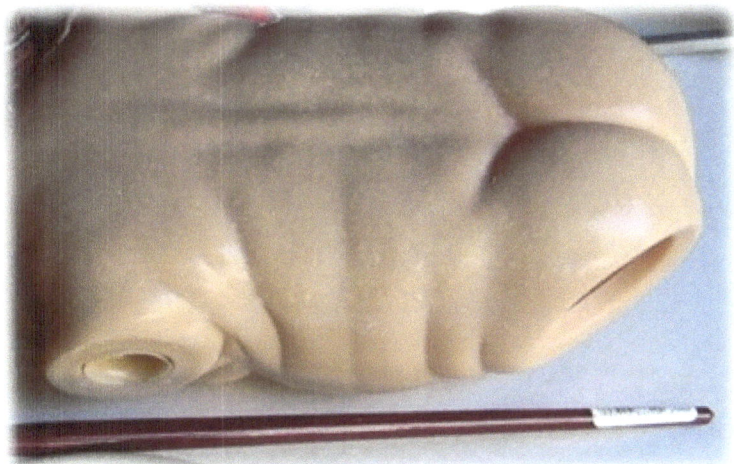

Depth Layer 1

To create our 1st depth layer we will add a dab of darker flesh tone color ie. Flesh, 03, or 05 or burnt sienna

and place it in your tray. Mix the colors and apply more thinning medium with your brush until you can see through to the plate

 underneath the paint. As you can see in the picture at left, it looks like we added a lot more paint to this tray, but in fact it is the extra thinning medium that is giving us the extra volume.

Continue to use the same sponge as the previous layer, and dip it into the paint mixture and blot off any excess on your paper toweling.

 Apply the color mixture to the vinyl with your sponge, dabbing around all of the body parts.

NOTE: If you have any difficulty reaching into the cracks and crevices of certain doll kits, then use your paint brush to cover those areas PRIOR to the start of your dabbing and blotting.

If you have any excess paint in any areas, blot it off with a sheet of paper toweling by placing your hand gently, but firmly over the vinyl piece.

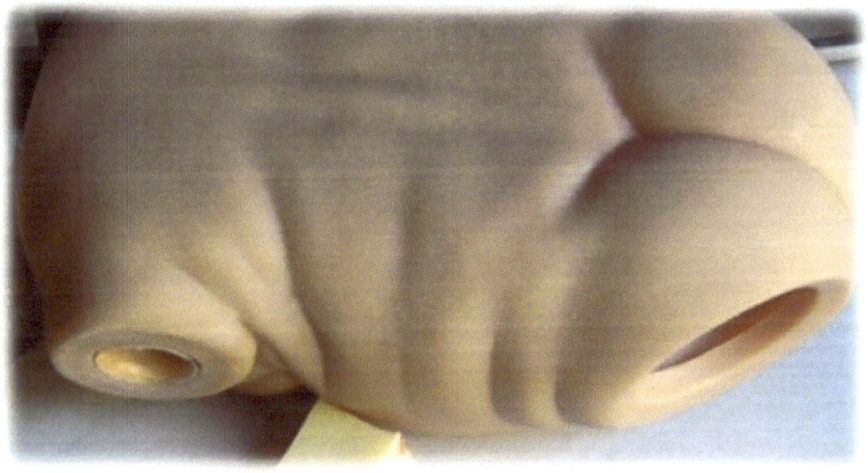

The first depth layer is now complete and you will start to notice some interesting variations to the skin tone on the vinyl. Don't worry if it looks funny at this stage, as each layer will get you closer to your final goal.

NOTE: Some people will want to do the head, limbs and body all at the same time, so that the exact same coloring is used throughout the reborn process. Over time, you may want to differentiate the head separately from the body. But for beginners, I would recommend to do them all at the same time.

Depth Layer 2

To create our 2nd depth layer we will take a dab of the red or crimson or magenta amd place it in the paint tray. Notice each

time we add a color, it's almost about the same amount. Although you can feel free to alter it (more or less) to fit your needs.

Mix the colors and apply more thinning medium with your brush just as you have done in the previous steps.

Dip your sponge that you had previously used into the paint mixture and blot off the excess paint on

your paper towel.

Apply the color mixture to the vinyl with your sponge, dabbing around all of the parts.

If you have any excess paint in any area, blot it off with a sheet of

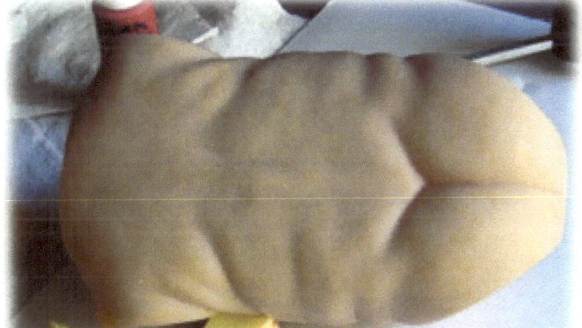

paper toweling by placing your hand gently, but firmly over the vinyl piece.

As you can see, the outcome is showing more depth and variations for that realistic skin tone of a newborn. The picture shown here is our "working" body (at left) compared to the base skin tone of the original special edition vinyl body (at right).

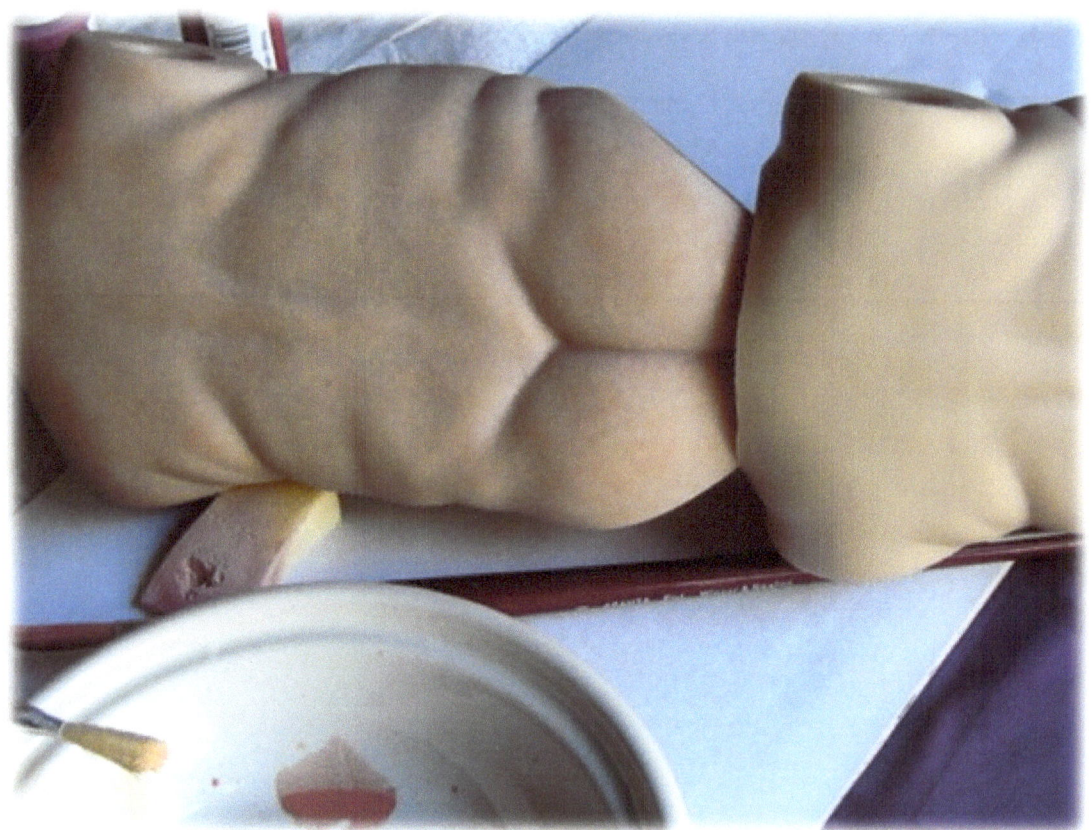

At any time in the process, if you reach the color and skin likeness you are seeking, you may stop and say to yourself "Good Job". Remember there is no one formula for a successful and realistic reborn. Each time I create one, I attempt to do something different and unique in order to assure my babies are completely one-of-a-kind.

Final Depth Layer

To create the final depth layer we will take a dab of the red and place it in the paint tray.

Mix the colors and apply even more of the thinning medium with your brush. Make sure you are able to see through to the plate underneath the paint. I tend to use more thinner with each layer to ensure that there is not too much paint, otherwise it can get to be too thick and noticeable. We want the colors to have sight-depth, but not so thick with paint. ☺

This time you want the sponge more dry than wet. Dip your sponge that you had previously used into the paint mixture and blot off on your paper towel before applying it to your doll's body part(s).

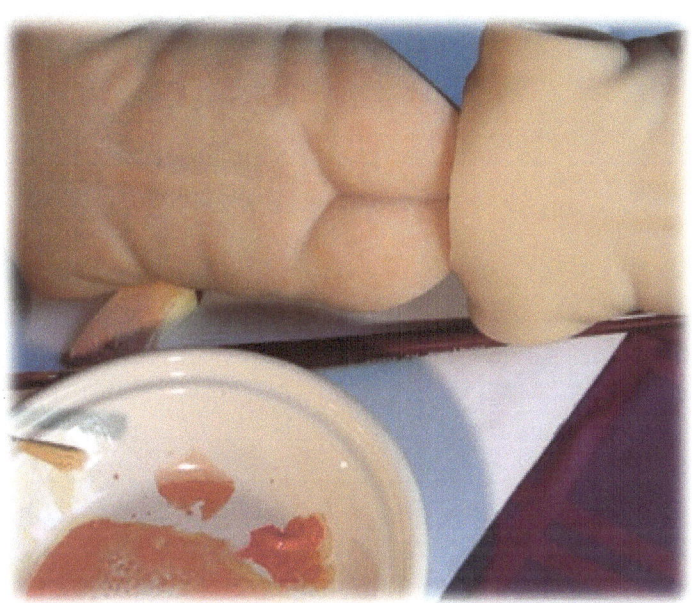

If you have any excess paint in any area, blot it off with a sheet of paper toweling by placing your hand gently, but firmly over the vinyl piece.

The outcome after this step is just simply fantastic shading, depth and skin tone variation.

Note: At any time in the process if you notice that your paint is just too thick in an area, and if the blotting of the paper towel does not seem to help, then take a sponge with only the paint thinning medium applied, and work to dab it over the excess painted area. Normally with enough dabbing and enough thinner on the sponge, each dab will start to remove paint from the area. I've even used this technique on purpose when attempting to thin out an over red spot on the vinyl body.

Heat Set Time

Be sure to give the vinyl pieces a "heat set" session after each layer. Once you are more experienced, you might want to experiment with applying the layers without the "heat set" session in between. But for the beginner, I recommend doing it one step at a time.

Additional Accent Layer (optional)

If you wish to show additional highlights for some of the more appropriately red areas of a newborn, you can use the same mixture you have in the paint tray at the end of the Newborn skin painting process.

You may use the same sponge you left off with in the last step previously. Simply dip it into the paint mixture and blot the sponge off on your paper towel. Then apply the paint with the sponge all over the areas that you wish to apply this accent technique. Chubby areas are best to accentuate.

For example, the accent areas, you would typically do the buttocks, shoulders, elbows, knees, bottom of the feet, in front of the ears, ear tips, neck, belly button, external nose areas, top of hands or any other areas you would like.

Pictured here is the original vinyl limb kit part at left, and the layered technique completed on the hand and foot which are shown at right in this picture above.

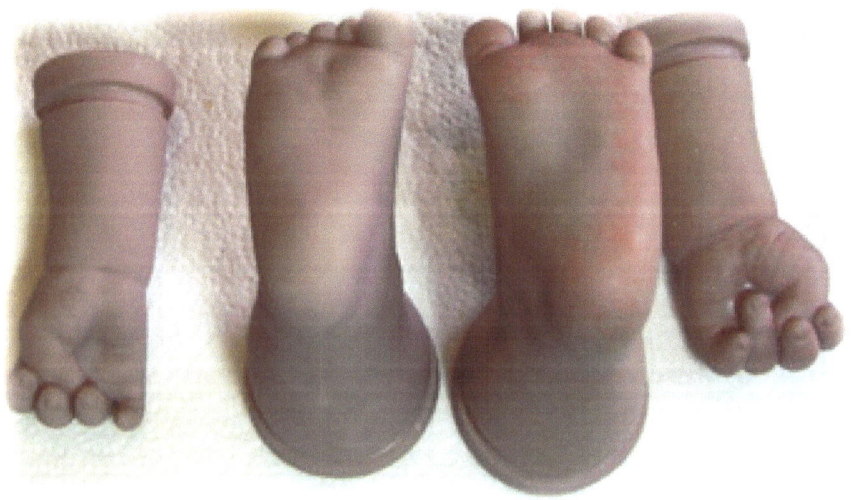

Looking at this sample below, you can see we have done the buttocks and the outside upper back shoulder areas. This is how it would look before the "heat set" session.

The picture below shows the additional depth and redness for the areas we have applied for accents.

You can actually see the body *come to life* while doing this technique. It is so much fun. The outcome is another fantastic layer of shading and depth with tonal variations.

Disclaimer: This information is not an endorsement for any one particular tool or product. It only gives you options and processes that have been successful for many reborn artists. Please respect your tools and use them for Reborn Artistry & Berenguer & other Dolls at your own risk.

For detailed information on special effects of Reborn Mottling, see *Excellence in Reborn Artistry™ Case Study #10 More on Mottling...* available at www.lulu.com/jeannine or www.rebornartistry.com books webpage.

Six Step Layering Technique

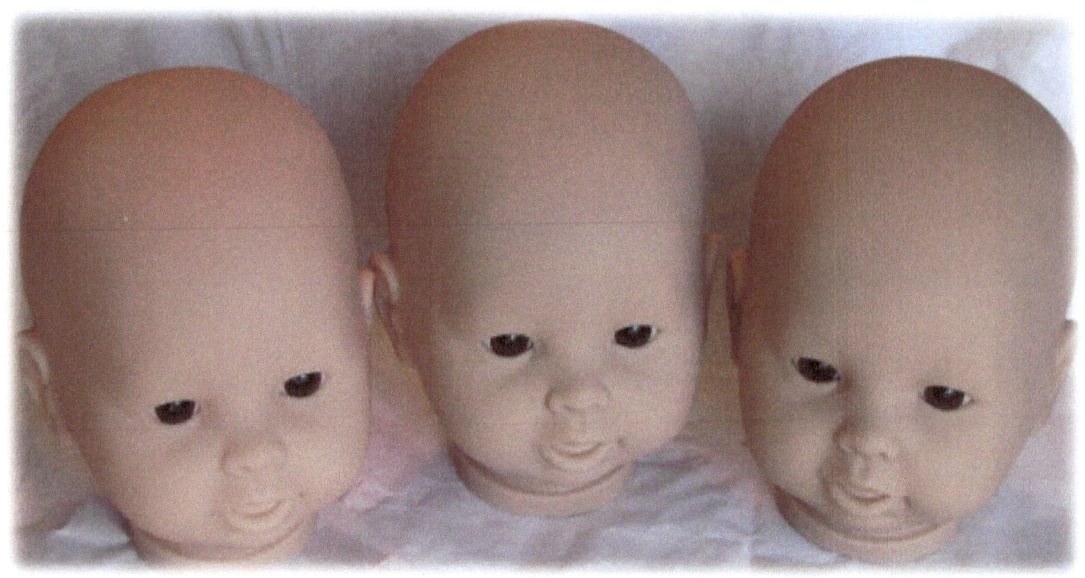

Asian Sample

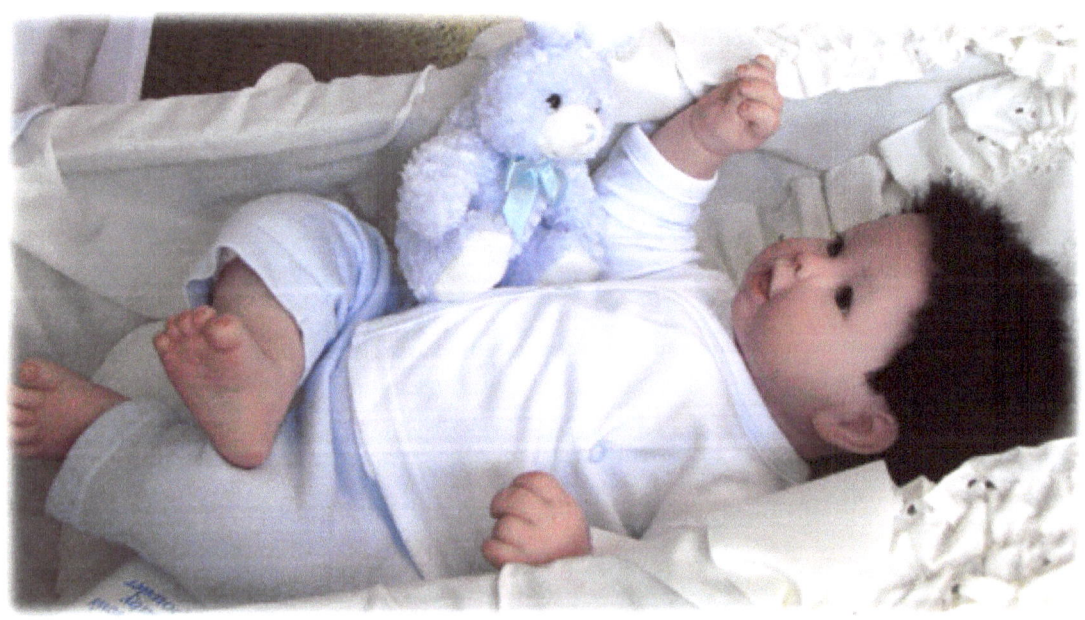

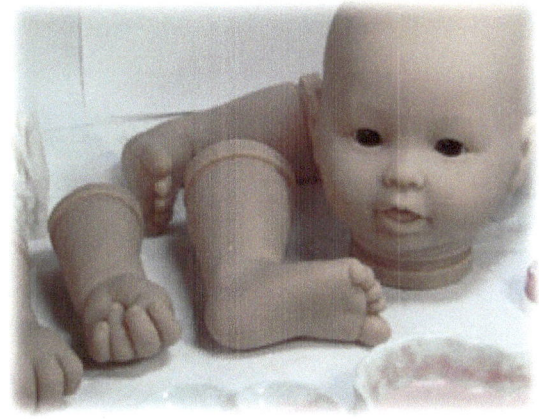
Layer 1 (white & flesh) Triangle Sponge

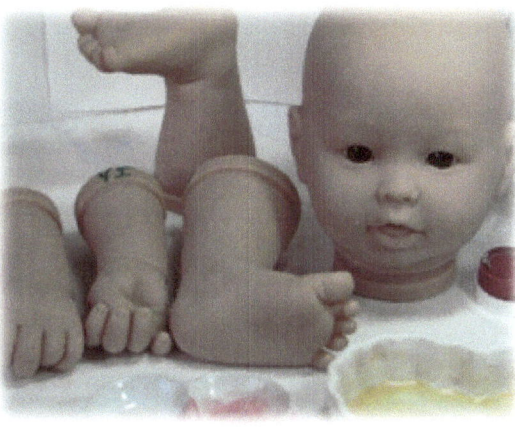
Layer 2 (add on yellow) Triangle Sponge

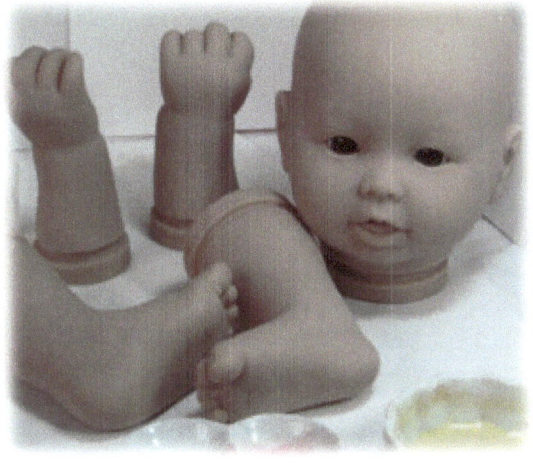
Layer 3 (add on flesh 08) Triangle Sponge

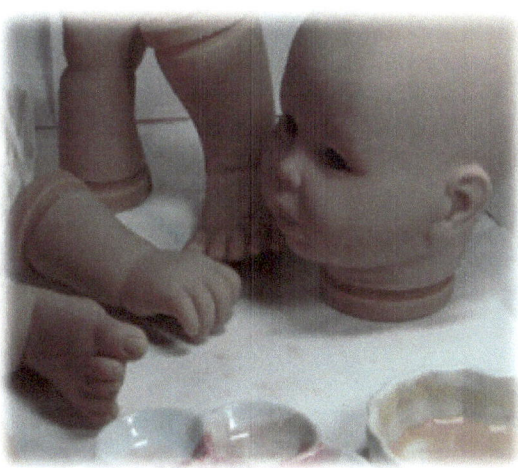
Layer 4 (add on flesh06) Triangle Sponge

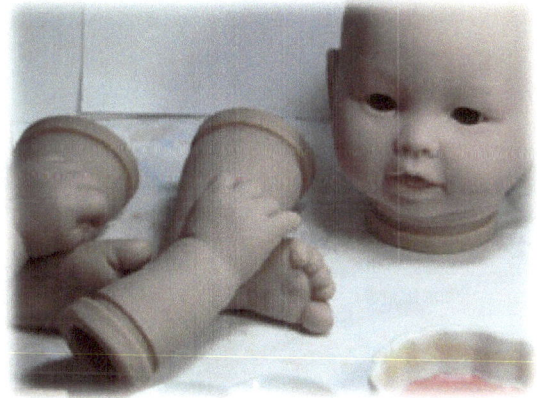
Layer 5 (tiny crimson) Triangle Sponge

Layer 6 (add on tiny red) Mop Brush

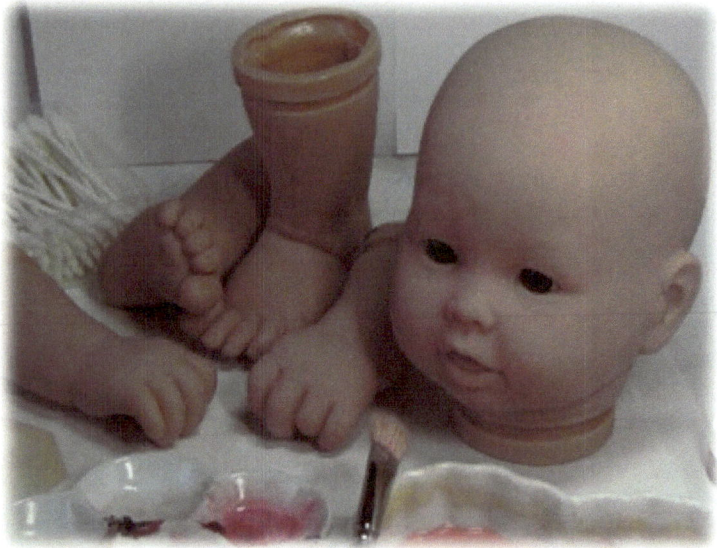

Details

We now create a soft brown using our mauve mix with a bit of any dark brown color for accents to all the creases and crevices, including the eyes, outer nose, lips, chin, and ears. Follow this by a "heat set session".

Then our next accents includes a tiny bit more red to our color mixture.

We use this to add on the initial rosie layers to the toes, fingers, knuckles, lips, ears, eyelids and nose.

I tend to use more thin colored layers in my work versus thicker single layer. Of course, you then complete a "heat set session".

Now is a good time to check to see if you need another layer on the finger nail beds or two nail beds, or lips before you apply your matte finish on these areas.

Once you are satisfied with these colors, then it is time for the matte varnish finish on the nail beds and lips.

I love the delicate shades of color on the feet, hands, elbows and knees; just a hint of pink and not too red for our Asian Beauty. She is now ready for hand hair rooting and eyelash application. Eye brows were applied using makeup sponge with soft brown color.

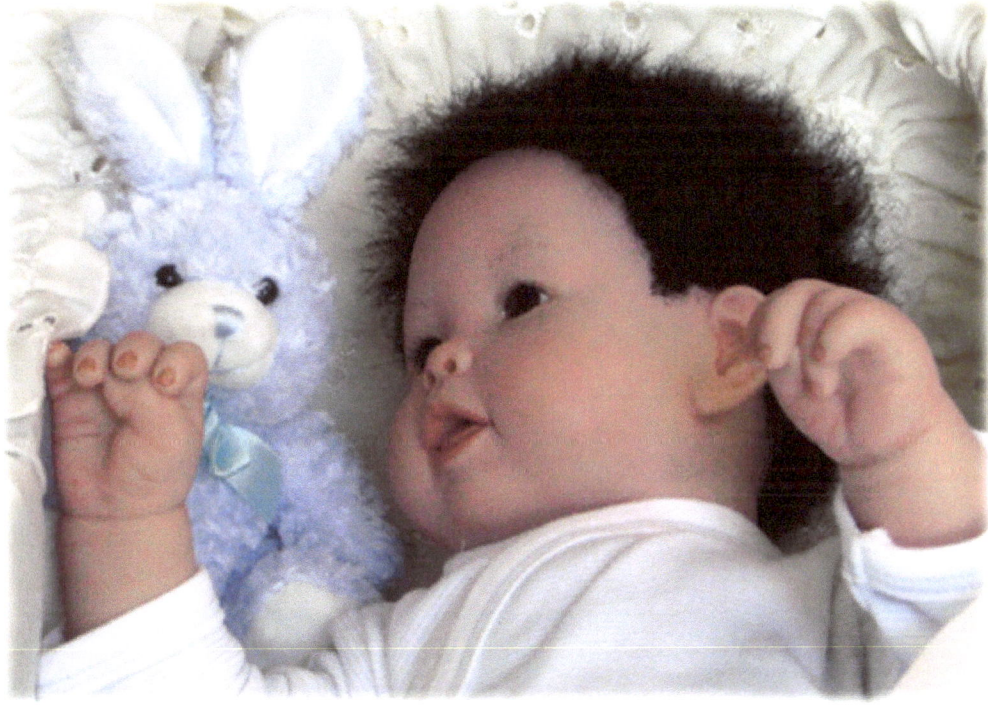

Six Step Layering Technique

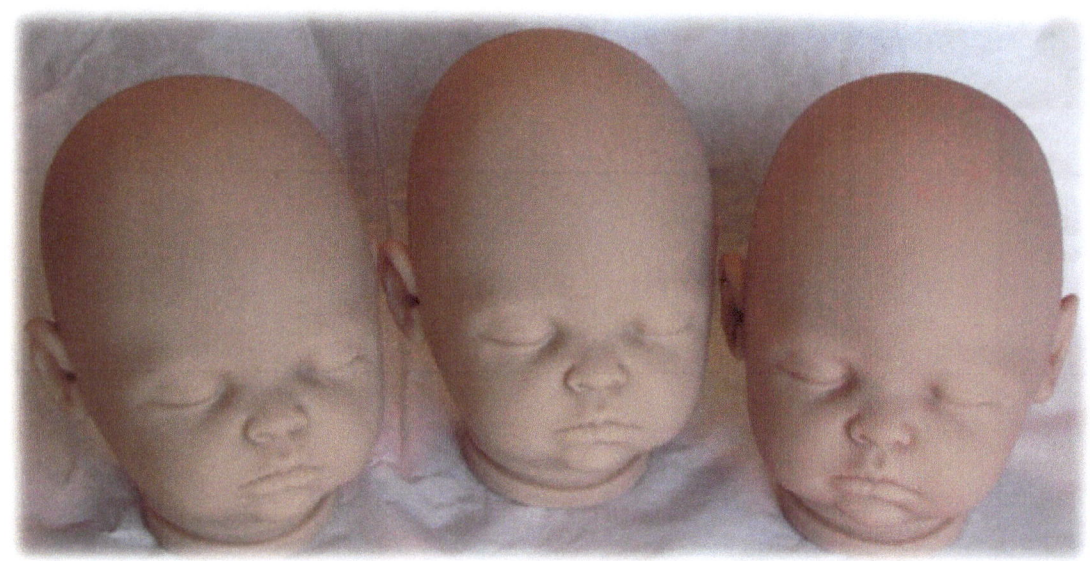

Caucasian Sample

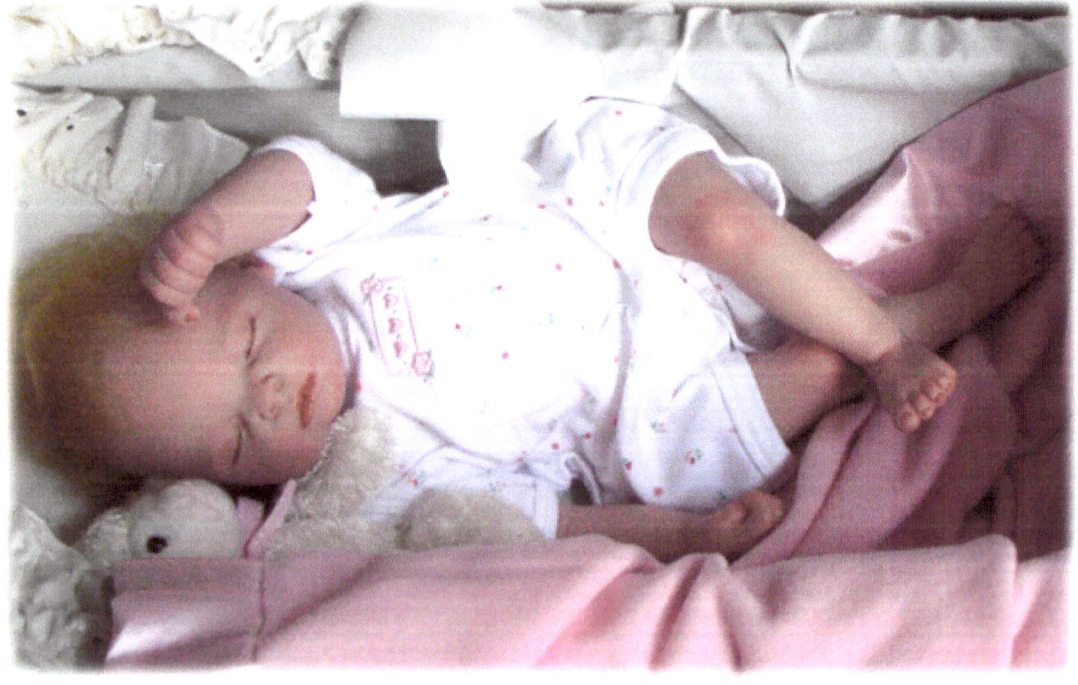

Layer 1 (white & flesh)

Layer 2 (add on yellow)

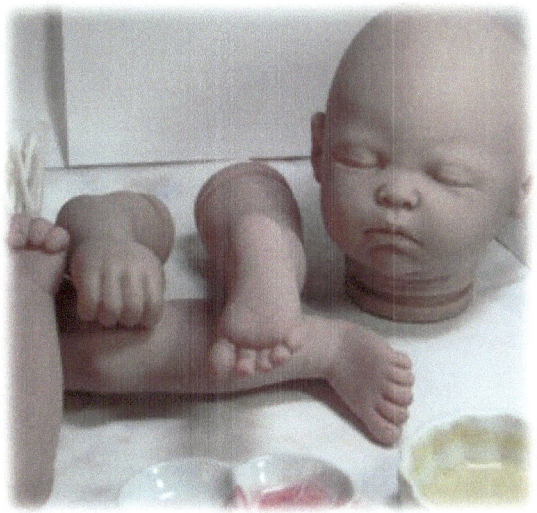
Layer 3 (add on flesh 06)

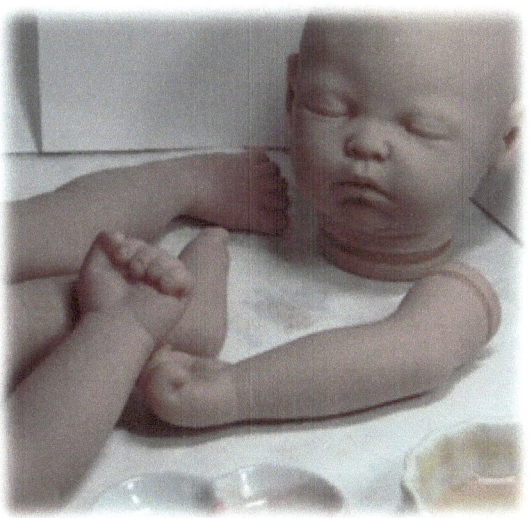
Layer 4 (add on burnt sienna)

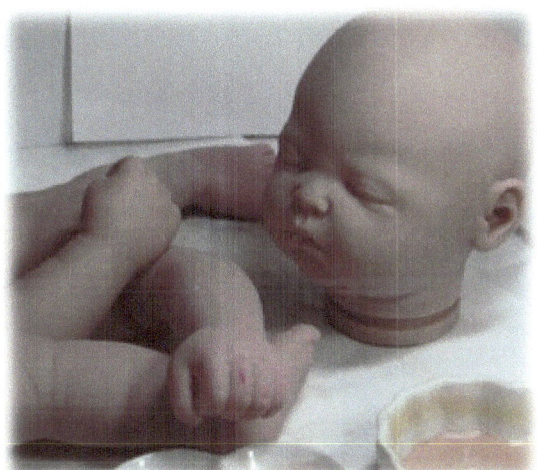
Layer 5 (add on tiny crimson)

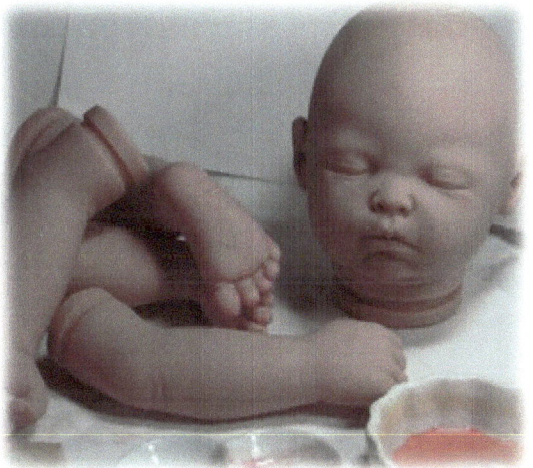
Layer 6 (add on tiny red)

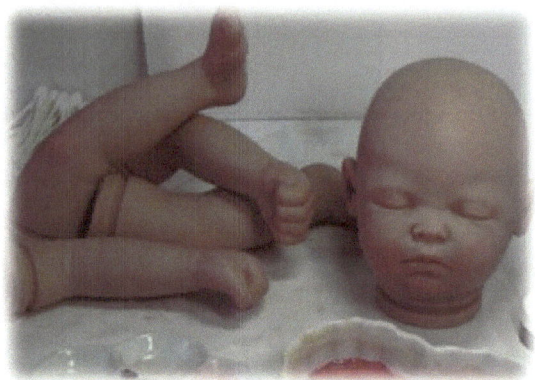
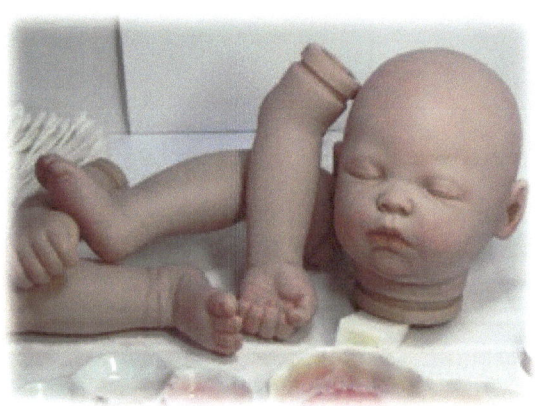
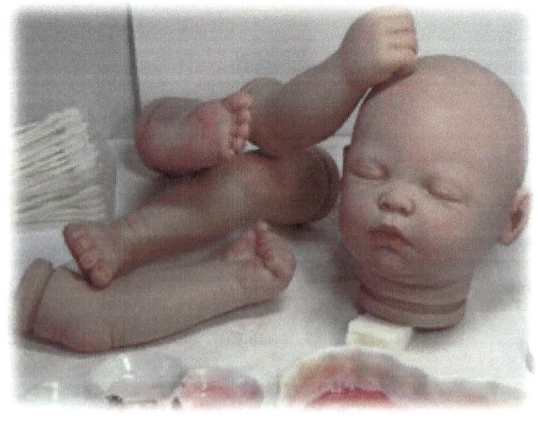

Details

We now create a soft brown using our mauve mix with a bit of any dark brown color for accents to all the creases and crevices, including the eyes, outer nose, lips, chin, and ears. Follow this by a "heat set session".

Then our next accents includes a tiny bit more red to our color mixture. We use this to add on the initial rosie layers to the toes, fingers, knuckles, lips, ears, eyelids and nose.

I tend to use more thin colored layers in my work versus thicker single layer. Of course, you then follow this by a "heat set" session.

Back again to the red accents, doing another layer of the soft brown mixture on the lips, inside the ears, and any other accent point you want just a hint of shading.

Now is a good time to check to see if you need another layer on the finger nail beds or two nail beds, or lips before you apply your matte finish on these areas.

Our final accents in review: check once more to see if the lips need to be a shade darker or more red.

Once you are satisfied with these colors, then it is time for the matte varnish finish on the nail beds, lips and eyes (if you want a moist look). Then do your final "heat set" session.

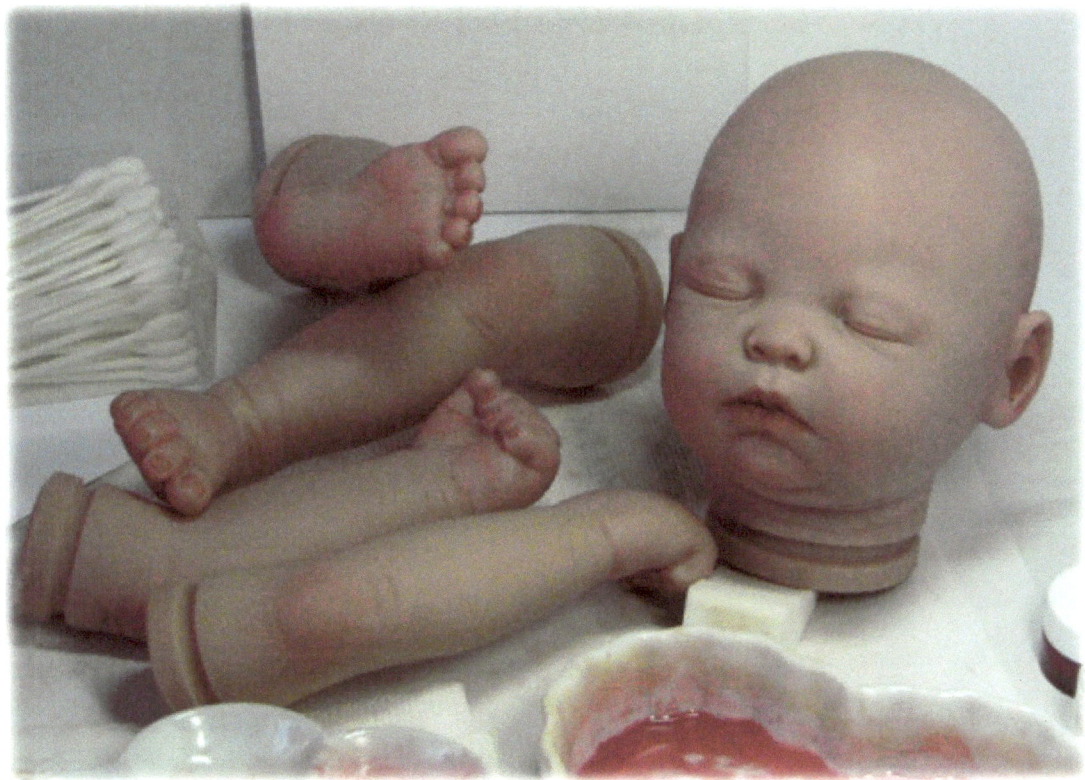

She is looking might fine indeed.

I love the delicate shades of color on the feet, hands, elbows and knees. She is now ready for my hand hair rooting efforts and eyelash insertion. I also hand painted in just a hint of an eyebrow on this sweetie.

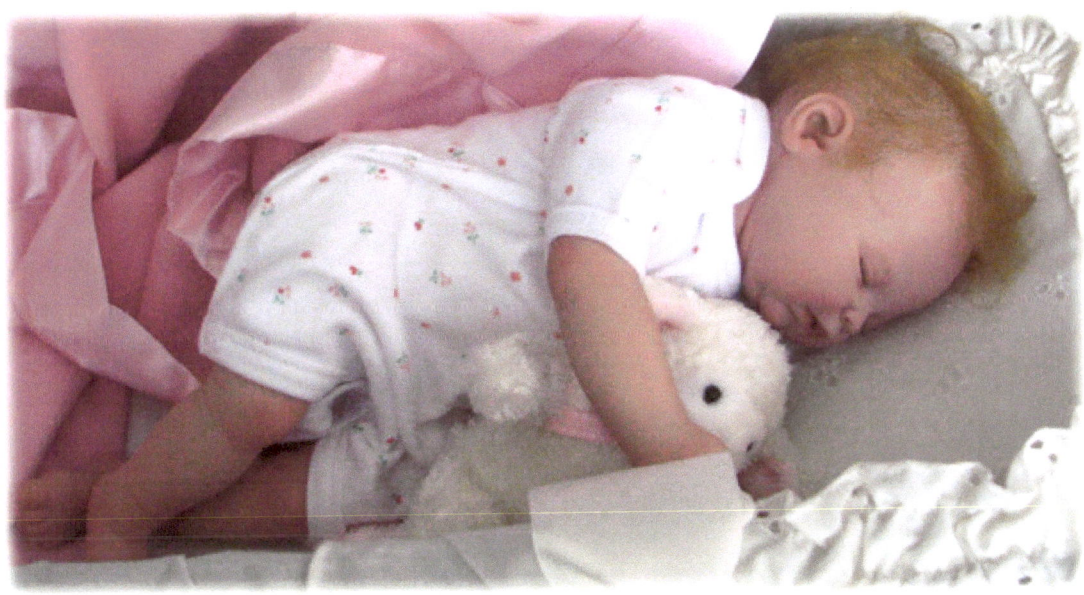

Six Step Layering Technique

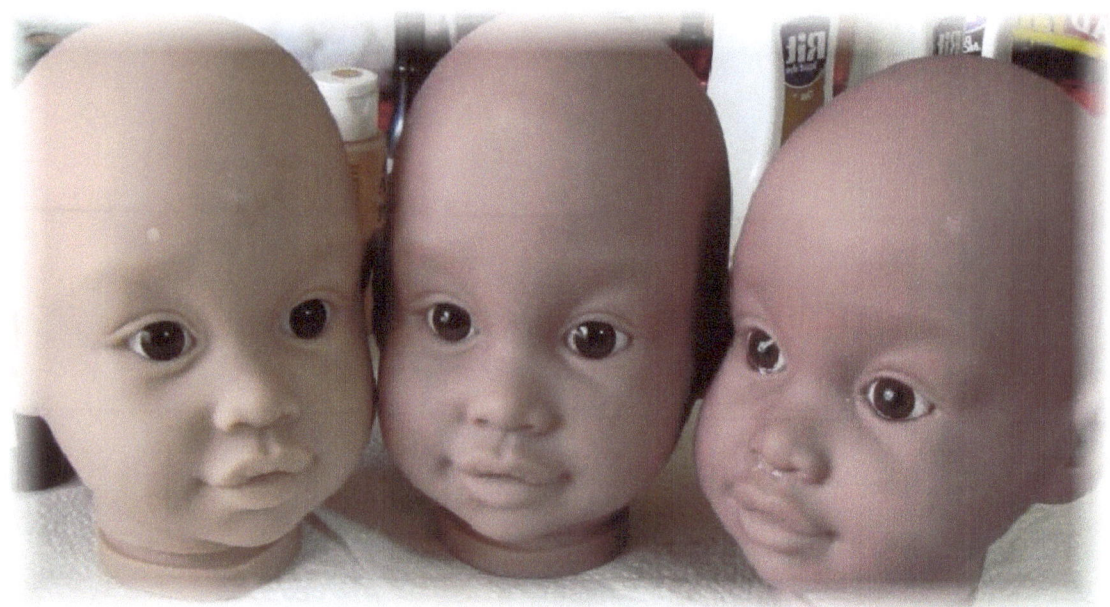

African American Sample

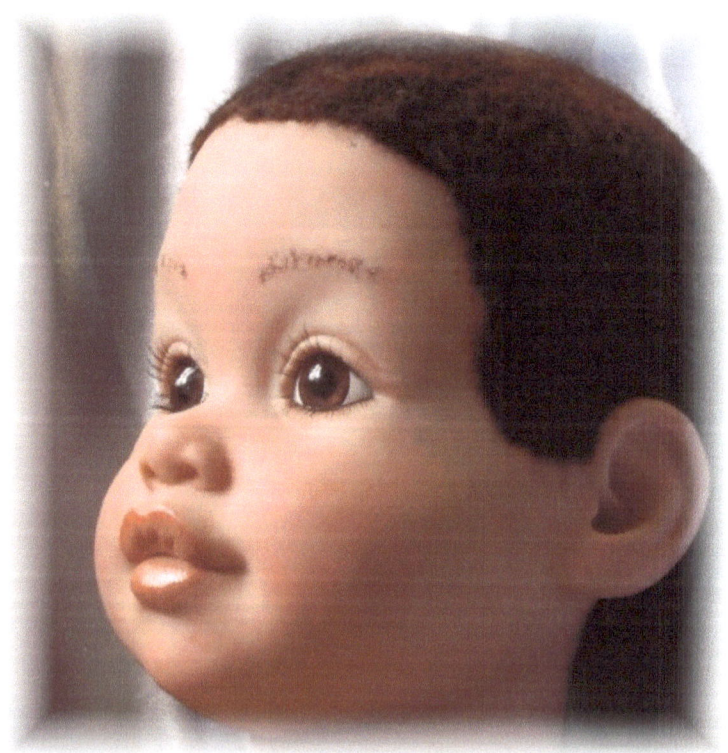

Six Step Layering Technique

In this example, I will use another color medium, just to show that this technique can be used with Oils, Acrylics, and Gouache, as well as Genesis Heat Set Paints.

Continuing the use of the basic colors of white, flesh, yellow, medium brown, dark brown, burgundy/rose and red, will allow you to create many skin layers that will create depth and variations for your ethic baby's precious skin.

These are the basic colors I use, but it is up to you to find the final blend that becomes your artistic signature. Do not worry if the color you have is a slightly different color or shade than the ones in this book, as any of the basic colors will provide you an amazing reborn with realistic looking skin tones.

Layer #1 – White / Yellow

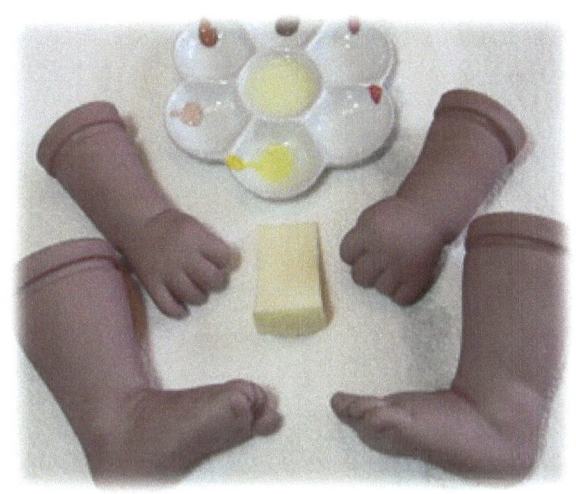

To create our base layer we will take a dab of White and Yellow color and place it in your tray. Mix the colors and add thinning medium with your brush to the color until you can see through to the plate underneath the paint. Apply the colors to the vinyl with your makeup pad or brush. Blend over the body for a very thin layer (almost to the point of not seeing any paint).

CURE-TIME (after each layer)

Be sure to give the vinyl pieces plenty of time to dry and/or cure after each layer. Follow the manufacturing instructions for your painting medium.

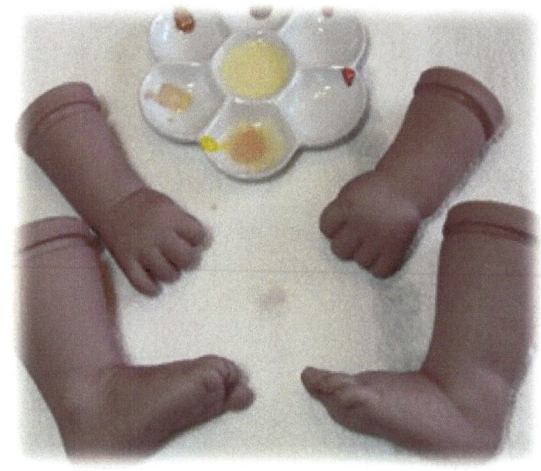

Layer #2 – Add on Skintone

Mix in a dab of the appropriate skin tone color and add more thinning medium. Continue to use the same sponge as the previous layer, and dip or apply the paint to your sponge. Apply to your doll parts as you have previously done.

Layer #3 – Add Medium Brown/Tan

Add in the Medium brown or dark tan color and mix well with additional thinning medium. Apply the color mixture to the vinyl with your sponge, dabbing around all of the body parts. Continue to use the same sponge as the previous layer, and dip it into the paint mixture and blot off any excess on your paper toweling.

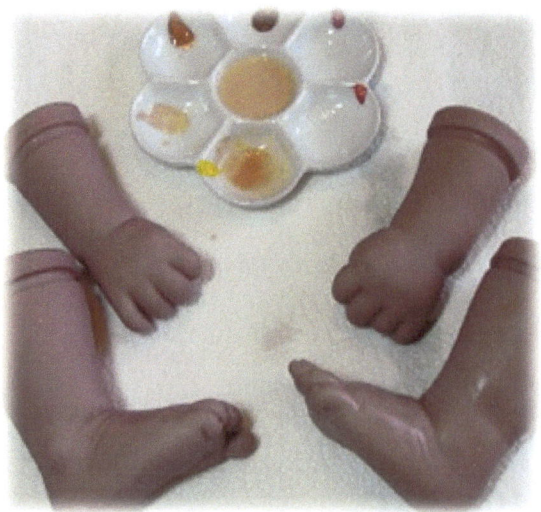

Layer #4 – Add Med Brown/Dark Brown

Add in the Medium Brown again, or the Dark Brown colors and mix well with additional thinning medium. Apply the color mixture to the vinyl with your sponge, dabbing around all of the body parts and blot off any excess on your paper toweling. This is also the layer where you might switch to your mottling sponge.

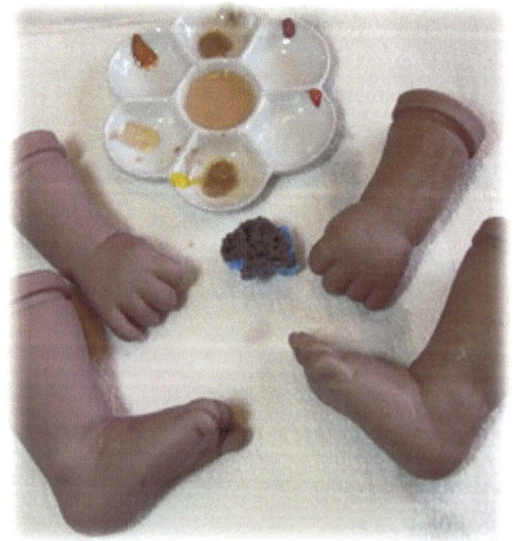

Layer #5 – Add on Burgundy/Rose, Pinks, Reds

Add in the Burgundy or deep rose color(s) and mix well with additional thinning medium. You can also add in the tiniest amount of your Deep Pink or favorite red color(s) and mix well with additional thinning medium. Apply the color sparingly to the vinyl with your sponge; blot off any excess on your paper toweling.

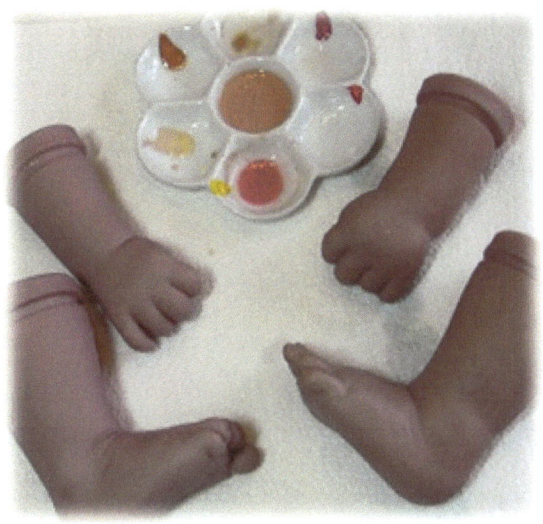

Layer #6 – Add on Reds; Final Layer and Accents

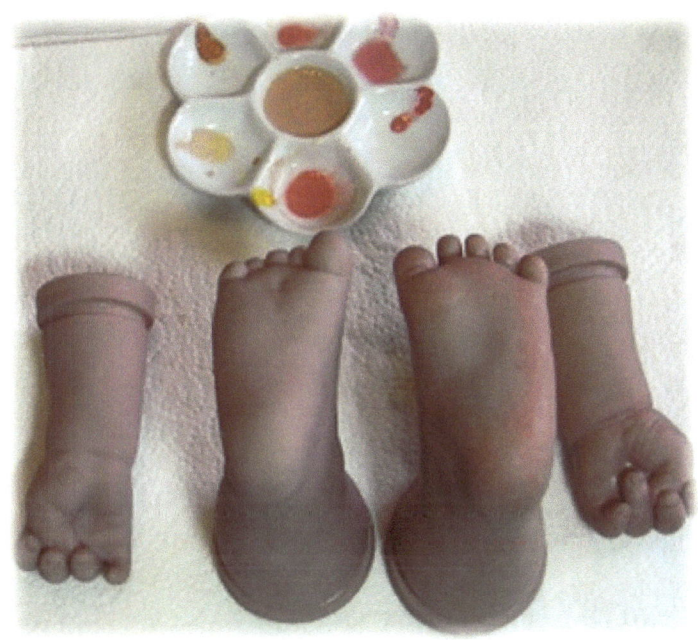

Continue to apply the paint with the sponge all over the areas that you wish to apply additional pink or reddish accents.

In the picture at left, you can see the difference between the color layering on the parts at right, versus the base skin tone of the parts at left.

Those original parts will be used for Ty's twin sister in a Peaches and Creams complexion style.

When doing your final detailing on your reborn, concentrate on the chubby areas, which are emphasized by intermediate folds. These are most typical for some additional rosie coloring.

You can add in more pink/reds to your color mixture, if needed; just remember to always add in additional thinning medium – 6 parts to 8 parts thinner to 1 part additional color. Accents need a very thin base, so it doesn't look like a painted doll.

Parts at left are base skin tone, parts on right have the layering technique applied.

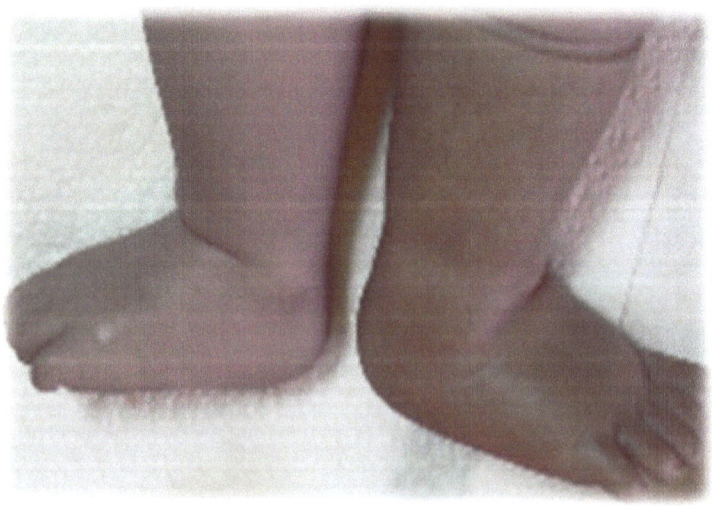

Picture Perfect

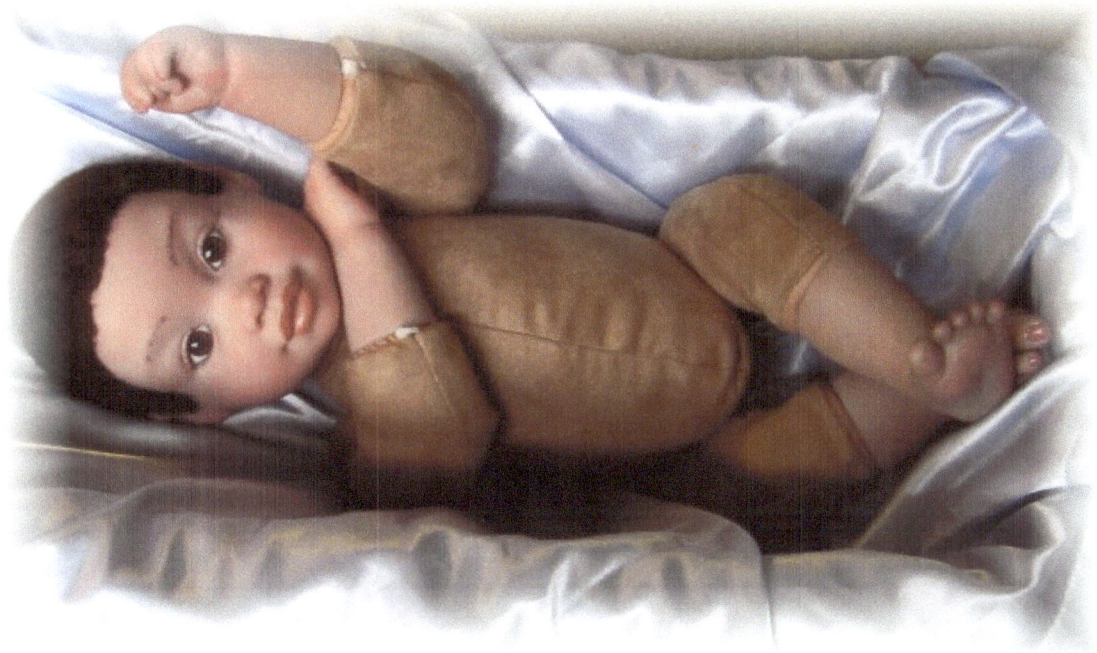

Using this 6 Layer technique will provide you the basics for any realistic skin tone application. Here he is shown in a new doe suede body by PatternsByJeannine™.

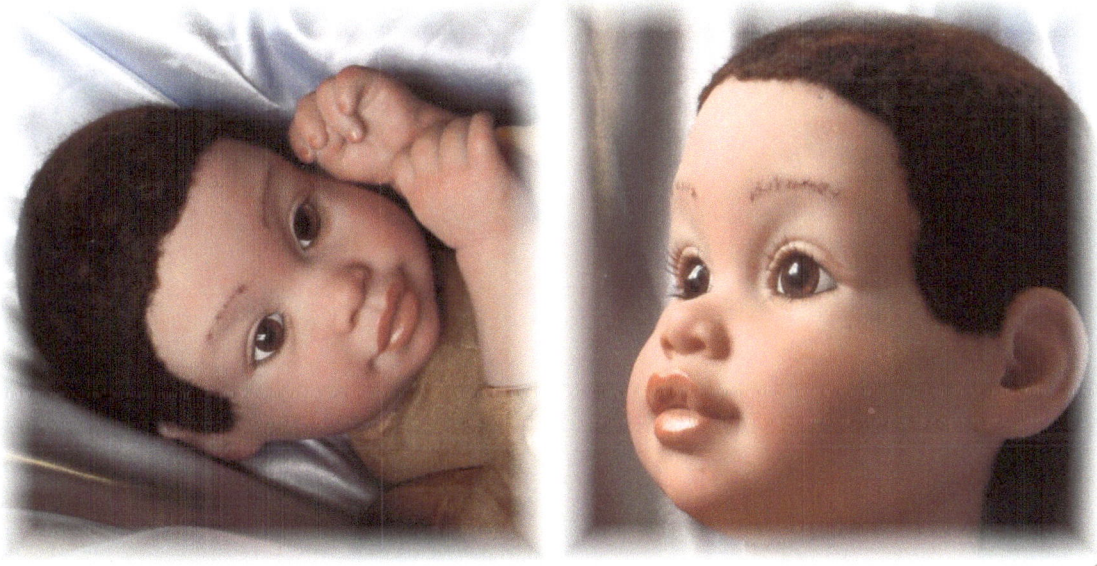

You can experiment with the application of the techniques using additional layers, different application tools, and various sponges to create unique and interesting results.

Excellence in Reborn Artistry™

Section 3

Body Accents, Facial Accents, Finishing Touches

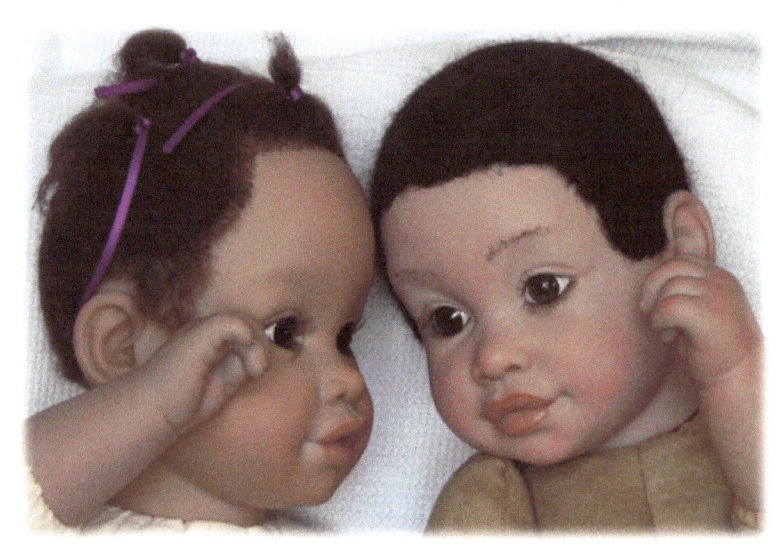

We have provided in the various sections bits and pieces of information regarding various accents for creases, crevices, body folds and highlights. We wish your reborns to have their skin folds meticulously blended with hand applied colors in your choice of specially blended pigments. Each one of the baby features should be custom applied, highlighted, and shaded to give your baby a realistic and healthy glow.

You can use oil and paint brushes, q-tips, and or makeup sponges to help you apply the colors together for blushing with sponges, soft brushes, or your blending cloth. When in doubt, use less blush color, and then wait to see the results in a few days. You do not want to over-detail, you simply want to

accentuate the baby features in the crevices, wrinkles and folds; as well as the hills and valleys.

Areas of Interest when Detailing...

ARMS... Upper shoulder, elbow, wrist, inside mountains of the palms, each and every knuckle, finger tips, finger nails (more on that in the manicure section)

LEGS... Upper thigh, knees, under knees, ankles

FEET... Folds by the heal, under foot soft pad, toes, toe joints, toe nails

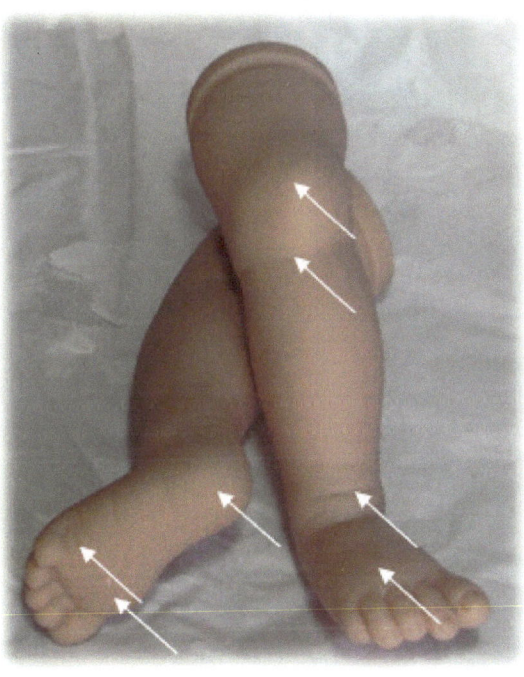

HEAD...

Nose: both inside and outside for shading; mouth, mouth creases, tongue and mouth arch inside, if open mouth baby; chin, cheeks, under eyes, eye lids, eye creases, eye brows, forehead, front area of ear, ear lobes, behind ears, inside ears, outer upper edge of ear; neck, back of neck folds; and fatty portions of folds.

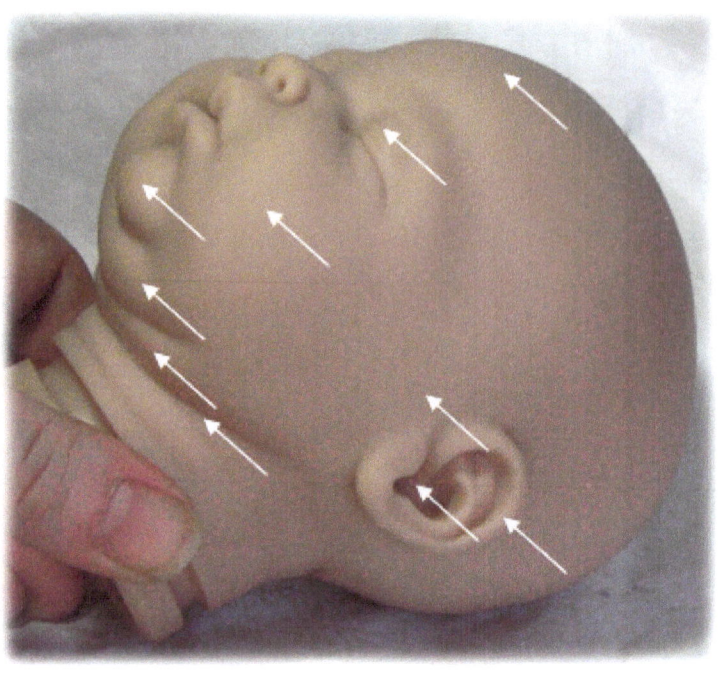

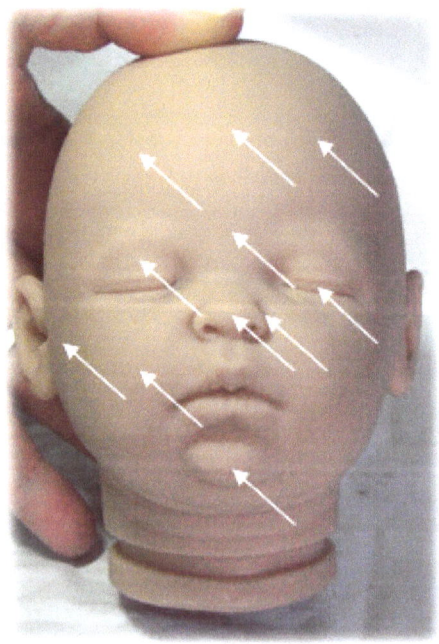

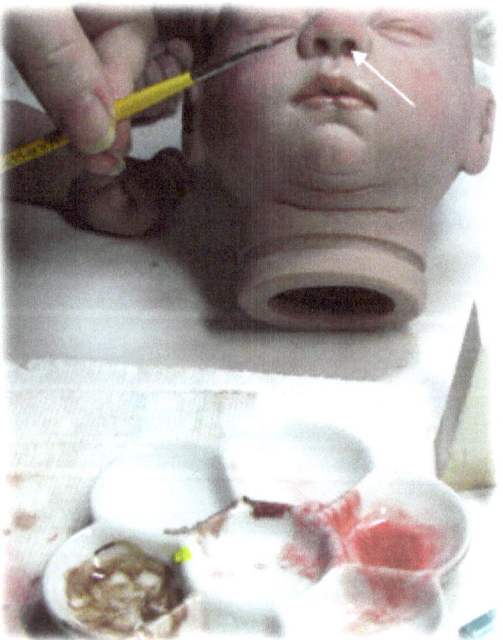

Picture at right shows the darker brown color to use after the soft brown, when you want more emphasis in your shading.

Veining & Mottling

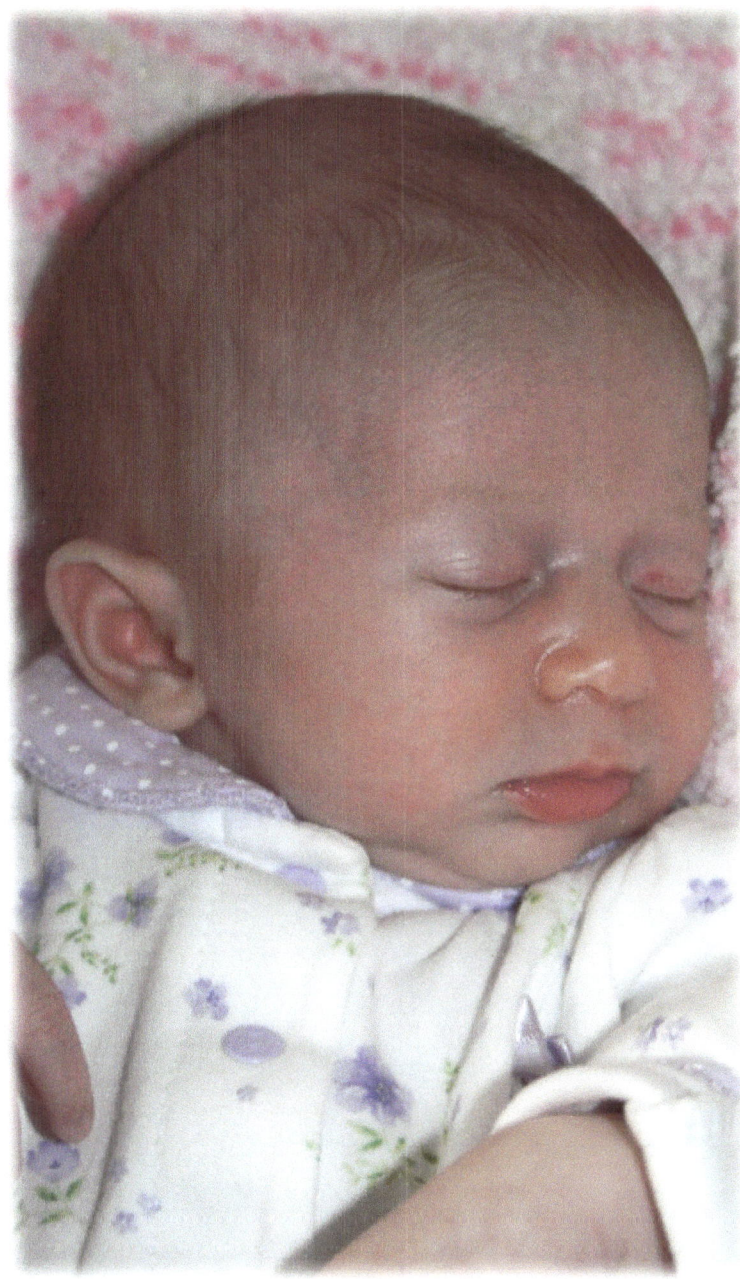

The Turquoise/Green/Marine Blue colors are typically used to apply the veins to the vinyl doll kit parts.

Thinned Burgundy colors work well for mottling arteries and capillaries.

Remember to blend/blush/pounce the vein strokes immediately upon application to the vinyl, as the some vinyl will absorb the paints ever-so-quickly.

Areas to consider for veining are: temples, forehead, neck, wrists, outside ankles, inside ankles, bottom and tops of feet, upper& outside hands. Search for baby pictures that show various veining possibilities.

Notice in the picture above her veining on the left of the forehead, bluish shading around her eyes, birthmark on the right eyelid and mottling effect on her hands.

For detailed information on Veining & Mottling, see *Excellence in Reborn Artistry™ Case Study #10 More on Mottling…* available at www.lulu.com/jeannine.

Veining

For the veining step of our Peaches and Cream complexion reborn, there is a wide variety of colors to choose from: Blue, Blue/Green, Turquiose, etc.

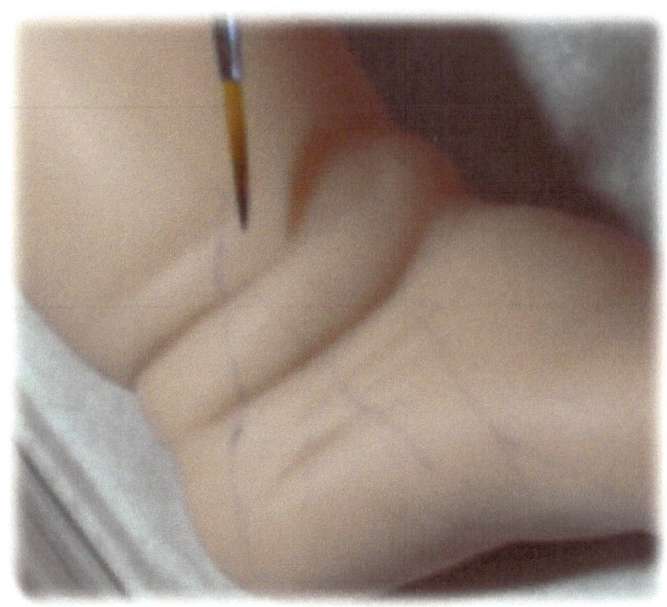

The secret is to use a very thin line when applying the colors to the vinyl. So use a thin liner brush or ultra thin edge to gather up the paint medium to apply to the vinyl surface. For the Genesis Heat Set Paints, I add in some thinner to a teeny tiny bit of paint, prior to applying the color; remove any excess color on your brush by dragging the brush across the paper toweling; and then finally apply the very thin veins.

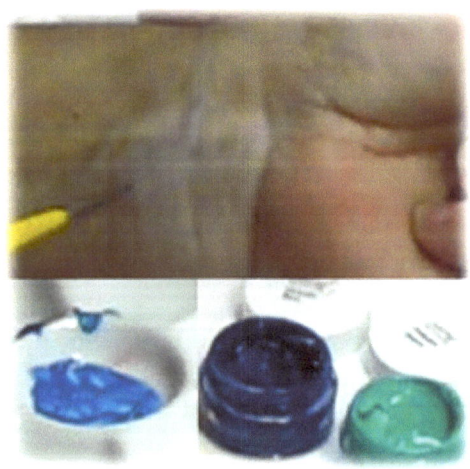

Let the colors sit there for a few minutes before using the application of a light dab of your make up sponge applicator over the area; be very careful not to drag or blend the applicator sponge. We just want to lightly remove any excess color for a more natural look.

Shown at left is a picture of the two colors I mixed to create the veining color. If you look at my wrist to where I have pointed with the paint brush, you can see the veins are barely noticeable.

When using the 6 step newborn layering techniques, the different size sponges will provide you different results when working the final layers of your baby's skin tone.

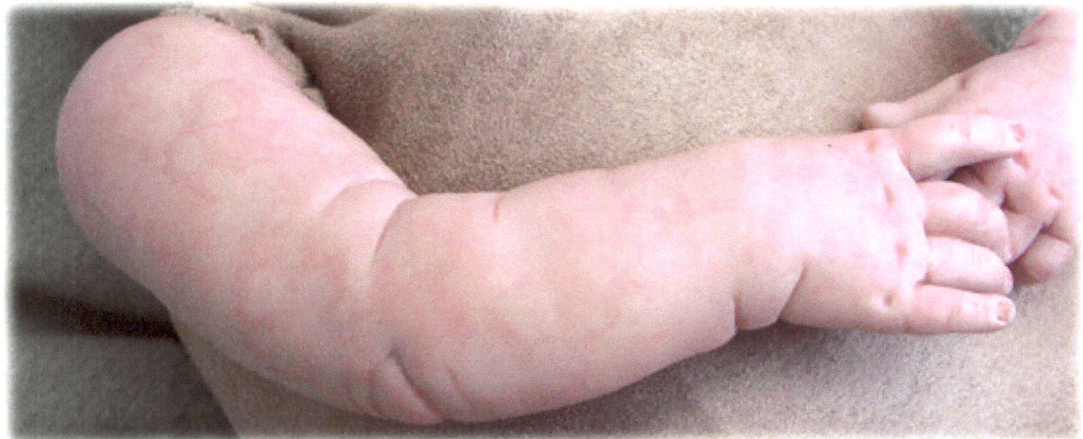

Find out more about these and other mottling techniques, which are shown in detail in our book *Excellence in Reborn Artistry™ Case Study #10 More on Mottling*… available at www.lulu.com/jeannine. You too can create your own Mottling tools.

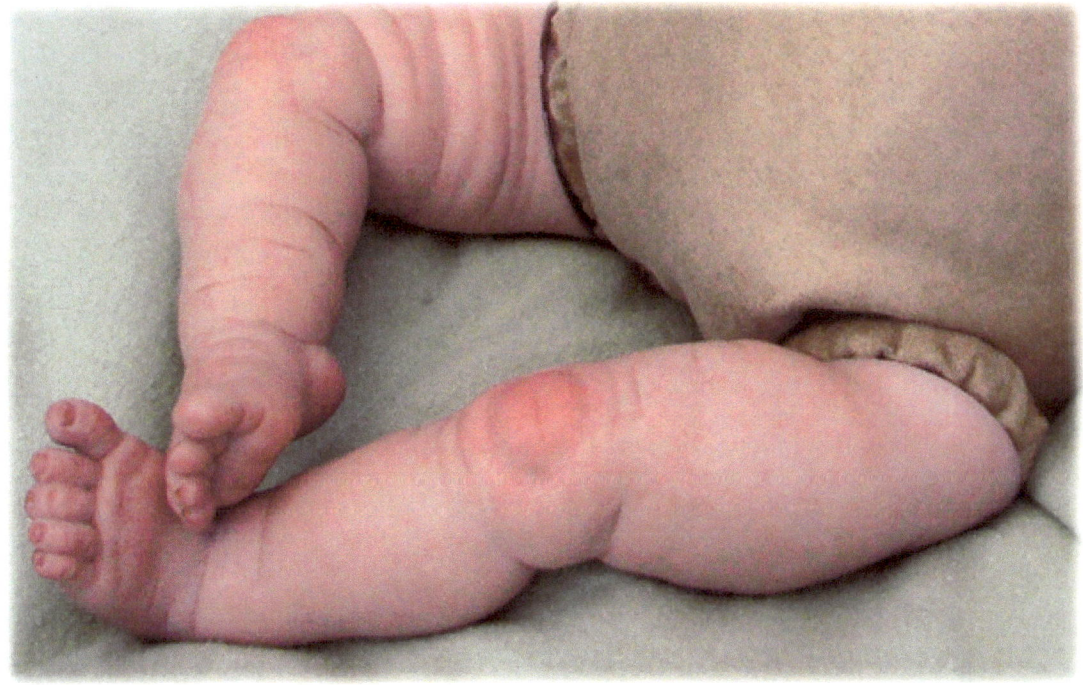

Facial Accents

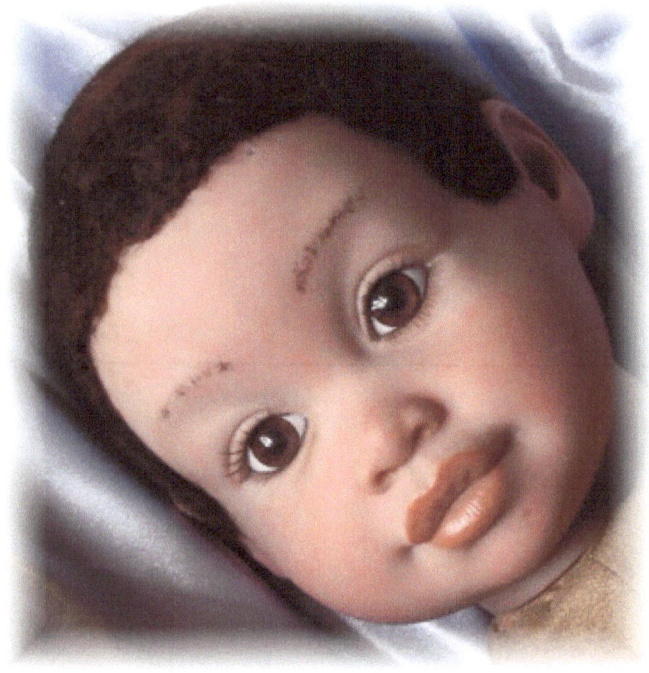

Eye Brows

Eyebrows can be hand painted, hand rooted, or even hand glue onto the vinyl. On our AA boy Ty, I've applied some matte finish in an eye brow arch; then lightly covered it with tiny slivers of mohair. Once set, I removed the excess mohair and the results are shown at left.

Painting on barely there eyelashes is an art form in itself. Many hours are normally needed in order to perfect the technique. The trick is to have a very thin eye liner brush with a minimal number of hairs.

One artist I know uses a brush with only 4 hairs when painting on eye lashes.

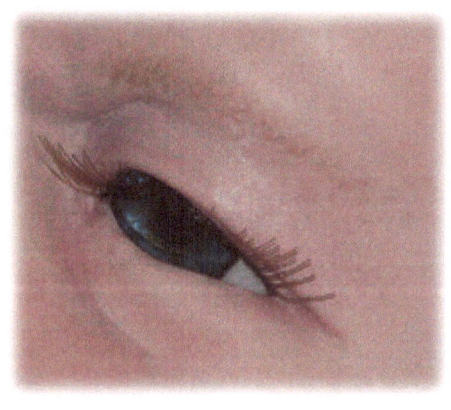

When rooting in eye brows, the most realistic results are achieved using individually hand rooted strands into the vinyl using a size 40 or 42 felting needle. Warm up the head first, which makes insertion easier, the holes less noticeable.

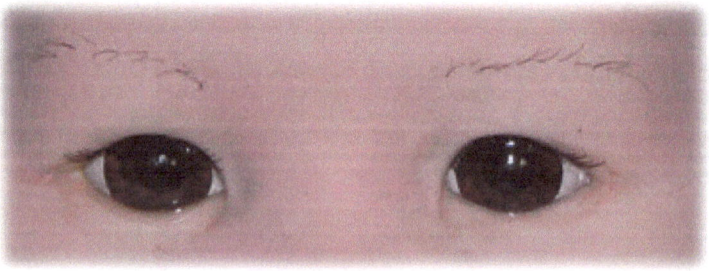

Eye Lashes

Eyelashes can be applied, or hand rooted into the vinyl. It's easy to hand root the lashes for a sleeping baby reborn, however much more difficult for an opened eyed doll as the doll's eye is normally in place when you attempt to root.

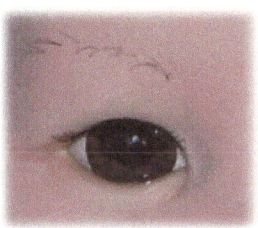

So many reborn hobbyists will just hand apply eye lashes on dolls with open eyes. As shown below, take the lashes that you have purchased, and line them up against the eye opening. Then snip them to the correct length. Position the lashes onto the crease between the eye and the vinyl, then glue in place.

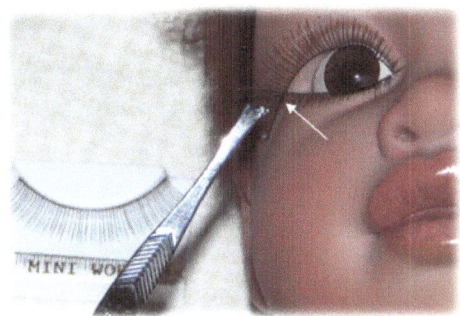

I normally use Aleene's Clear Gel Tacky glue for attaching doll eyelashes most of the time. It is an excellent adhesive and allows you plenty of time to get the lashes positioned correctly. It is also easy clean up if you make a mistake.

CAUTION: <u>Do not use</u> any form of super glue on your eyes. Once they touch the surface, they will permanently dull the eyes appearance.

Glossy Lips, Sleepy Eyes & Baby tears

To create moist realistic looking tears, or add wetness to open or sleeping eyes, Aleene's Paper Glaze is a fun product to use.

For Wetness: you can apply with any detailed application brush; use just a very thin layer. Apply directly to the creases of the sleeping eyes with an overlap on the vinyl if you wish. Drying time should be at least 24 hours (and possibly 48 hours for larger tears).

You can also use it inside the nose, to make your

reborn appear to be more alive. This has been done on our sample on the previous page. As a matter of fact, how many babies do you know that have dry noses. ☺

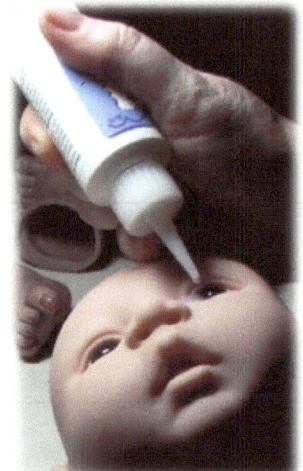

For Tears: apply to the eyes and leave on enough product so that a drip will form at the edge of the eyes and allow it to slightly drip & dry.

The trick is to allow the drip to form to the length you desire (see pictures below). Then position the head at an angle over an object (like a bowl lined with protective plastic wrap shown at right), so that the tear bud will end where you wish it to be.

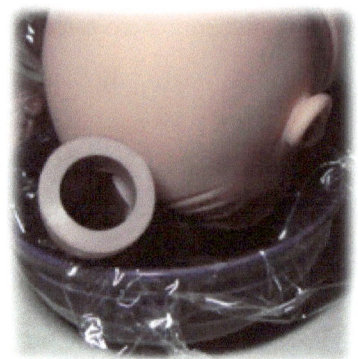

Otherwise the tear will continue to drip down the face and off the vinyl.

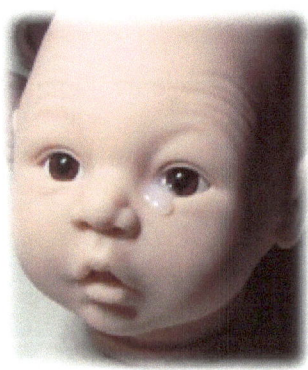 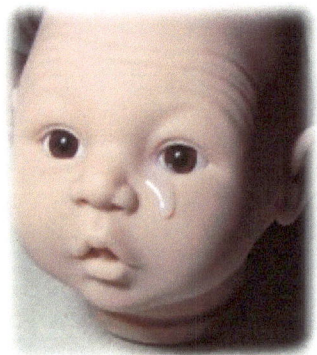 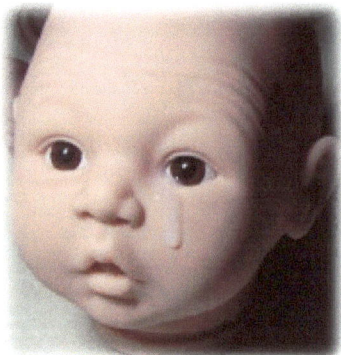

Practice on a spare piece of vinyl before you apply to the eyes and cheeks. Drying time for a tear drip bud to show clear is typically 2 to 4 days.

There are other uses for this wonderful product, but you need to use your imagination. Just remember to allow it sufficient time to dry before it is touch.

Picture at right → clear after 4 days.

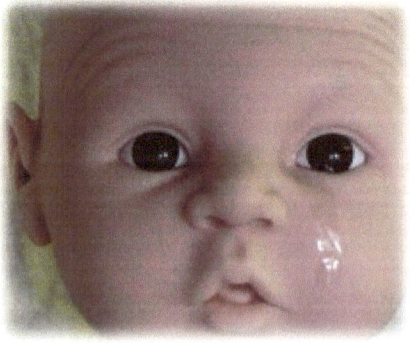

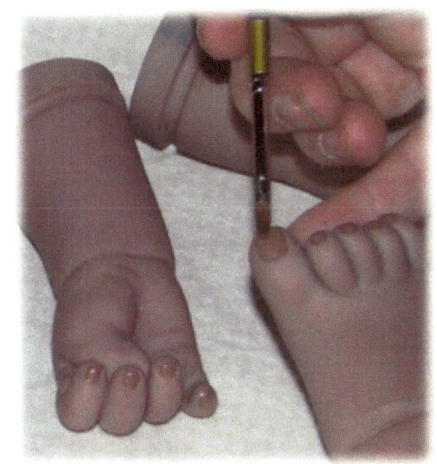

For Manicures: It is great fun to see the colors bring your reborn to life as you go through each step in the coloring application process. Once the colors are applied; then continue to the next step of sealing the nail beds of your finger nails and toes. You can apply color to the nail beds which are slightly lighter or slightly darker than the skin tone color you've selected for your reborn.

Satin Sealants & UV Protection

As with many of the painting methods for reborning, it is highly recommended that you use a surface sealer once you are finished with your baby to protect and preserve your reborn creation. GHSP has the Heat Set Permanent Matte Varnish product to use.

When using GHSP Matte Varnish, work or mix it up well; place the amount you are going to use on a larger porcelain tray, which will allow you a bigger area to work the medium into a thinner consistency (you can apply a bit of thinner if you wish).

Then use your makeup sponge applicator and pounce all over the vinyl you wish to have the GHSP Matte Varnish finish applied.

I find it is better to do two thin layers and "heat set" in between each layer, versus one thick layer with one "heat set" session. If you decide to do this layer of protection, make sure you apply it <u>prior to</u> the application any of the glossy detailed work.

Excellence in Reborn Artistry ™ Learn To Paint **Part II**: Genesis Heat Set Paints

CreationsByJeannine™
Excellence in Reborn Artistry™ Books, eBooks, & CDs
Instructional, Informative, Guidelines, Tips & Techniques

Always available at www.lulu.com/jeannine

Back Front
300 Full Color Pictures

Learn the Art... Soft Cover Books & eBooks Available. **Create Breathtaking Reborn Baby Dolls.** You take a simple vinyl doll and transform it to a One-of-a-Kind Heirloom Collectible. This book provides you the knowledge to Reborn Vinyl Dolls and Dolls By Berenguer Reborns and includes an instruction manual for Beginners and Intermediate Reborn Artists. It is a great book for Artists-in-training, as it has been used by instructors around the world to teach this wonderful art form.

The book includes 14 overview sections: Supplies, Disassembly, Bathing, Blushing, Soft Body, Facial Features, Subtle Veining, Magnets, Pacifiers, Juices, Milk Bottles, Stuffing and Weighting, Baby Fat, Manicures, Heart Boxes, Heat Pouches, Making Umbilical Cords and also has many Life-Like Reborn Samples, Reborning Tips, Techniques and more...

 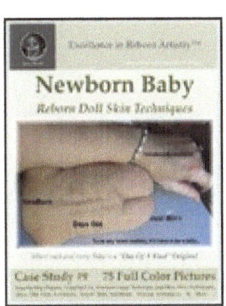

Back Front
75 Full Color Pictures

Breathtaking Reborns with Realistic Newborn Skin tone... You can take a simple vinyl doll and transform it to a One-of-a-Kind Heirloom Collectible. This book features techniques for Vinyl Reborns and is an instruction Manual for Advanced Beginners and Intermediate Reborn Artists. It covers the technique to reborn the most realistic preemie and infant with just born skin tone techniques. The book includes: Supply basics, Layering Techniques for Newborn Skin, Just Born Skin, and Days Old Skin tones. External and Internal veining discussion is also included. Our most popular Case Study for two years running...

 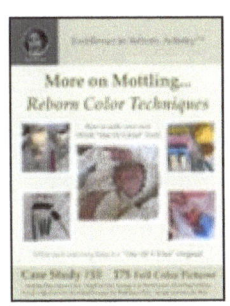

Back Front
175 Full Color Pictures

More On Mottling... This book continues the discussion on mottling skin reborn techniques for Vinyl Reborns and is an instruction manual for Advanced Beginners, Intermediate Reborn Artists, and Hobbyists. It covers the technique to reborn the most realistic preemies and infants with just born skin tone techniques. The book includes: Supply basics, Recap of the Layering Techniques for Newborn Skin, Discussion on Sponges and their uses, Step-by-step instructions to create several custom OOAK tools for your own reborning needs. It also includes interesting application Variations for veins, arteries, capillaries and other features.

Back Front
Full Color Pictures

ALL 6: SOFT BODY PATTERNS. Reborn Vinyl and Silicon Vinyl Dolls 32 sizes / Patterns / Configurations / Style Combinations
Stable Soft Body Patterns – Fits Most Berenguer Dolls 1: Non-Jointed Soft Body Full Limbs – 10 sizes 2: Jointed Soft Body Full Limbs – 9 sizes 3: Oval Soft body ¼ Partial Limbs-4 popular sizes Oval Soft Body Patterns – Fits Many Silicon-Vinyl Dolls 4: Artist Dolls like Baby Emily & Alex – 4 sizes 5: Artist Dolls like Sheila Michael – 4 sizes 6: Jointed Oval Soft body Pattern Full Limbs- 4 popular sizes combinations

Find all our Books, eBooks, and Movies on CD at www.lulu.com/jeannine

Back Front

85 Full Color Pictures

Beautiful Heirloom Reborn Babies with Realistic Hair... This book will take you through the detailed steps involved in creating a reborn with Realistic Hand Rooted Hair. It features the hair rooting process for several dolls for you to see the steps involved with Mohair and Human Hair Rooting and Techniques. From the basic Hand-Rooting to Mini-Rooting, Micro-Rooting and the new Ultra-Micro technique. These techniques can be used on Vinyl and Silicon-Vinyl dolls. Includes supplies list, Step by Step Instructions, and Tips & Techniques. A very popular Case Study #6 in the Excellence in Reborn Artistry™ Series.
New MOVIE on CD available to compliment this book.

Back Front

750 Full Color Pictures

Excellence in Reborn Artistry™ MASTER COLLECTION - The BEST OF SERIES... This book is updated every few years to include the most popular Books in the series. Instructional and Informative with guidelines, tips & new techniques... Always includes the most popular book Learn the Art (the Basic & Intermediate instruction books), as well as 4 of the most popular Case Studies which provides in detail the many facets of Reborning. This book would not be complete without our most popular 6 Soft Body Pattern Booklets with Step by Step instructions and full color pictures. **Our MOVIES on CD compliments this Best of Series Book nicely.** 12 Books/Booklets.

Back Cover Front Cover

300 Full Color Pictures

Collector's Edition Book (Parts 1 & 2, plus Bonus Materials). Learn to use Paint using Genesis Heat Set Paints on Newborns, Toddlers and Reborn Dolls. The perfection of Peaches and Creams Complexion, along with Newborn Skin Layering Techniques! PLUS bonus materials you will not find in Books 1 or 2 of the series. Includes: Internal "color wash" application techniques; External color application methods; AND Bonus Section on liquid dye methods. Our featured Secrist dolls in this book are Zoe, Ming & Starling; PLUS in addition Taffy - a wonderful example of medium skin tone newborn layering techniques. This full art book also touches on Veining, Facial Accents and Body Art options; bonus materials include wig application. Wonderful techniques that can also be used for acrylics, oils, gouache and more... **Get the Companion Movies on CD.**

Back Cover Front Cover

100 Full Color Pictures

Learn to Paint PART 1 of 2: Peaches and Creams Complexions. Learn to use Genesis Heat Set Paints to create the most beautiful Collectible & Heirloom "One of a Kind" Dolls. This art book provides the following valuable information for the beginner: Create your base skin tone from the inside with Internal "color wash" application techniques; See the Peaches and Cream Complexion techniques come alive on three of the Secrist doll kits: Zoe, Ming & Starling; A wonderful technique for your perfect baby or toddler. Also includes Facial Accents including sleepy eyes and Body Art options; sure to create a heirloom and/or collectible doll. Bring to life, your own Custom Reborn Baby; Isn't it time for A Precious Heirloom Baby of your very own? **Companion Movie on CD available.**

Find all our Books, eBooks, and Movies on CD at www.lulu.com/jeannine

Back Cover Front Cover
150 Full Color Pictures

Learn to Paint PART 2 of 2: Realistic Newborn Layering Techniques. Can you imagine a baby so perfect, it looks just like it was newborn? If you need light, medium and darker skin tones with a hint of the blotchy effect and a touch of mottling, then this is the book for you. This art book provides the following valuable information for the beginning artist or reborn hobbyist: Create your base skin tone from the outside with external application techniques; See the Newborn and Just born painting techniques shown on three of the Secrist doll kits: Zoe, Ming & Starling; A wonderful technique for newborn baby in your life. Also touches on Veining, Facial Accents including tears and Body Art options; sure to create an heirloom and/or collectible infant doll. Bring to life, your own Custom Reborn; So realistic, your friends will think it is a real newborn baby. **Get the Companion Movie on CD, which compliments this book nicely.**

Back Front
300 Full Color Pictures

Learn the Most… COLLECTORs EDITION - HARD COVER & Soft Cover BOOKs Available. Finally a place where can you find the most color mediums described in any one book in the Excellence in Reborn Artistry™ series. Learn all the most popular color mediums used in the Reborning and Doll Making Hobby Industry. Paint mediums include: Oils, Acrylics, Pigment Inks, Stencil Cremes, Genesis Heat Set Paints, and even a touch on Gouache. This book includes six large sections: Apply Base Skin Tones; Blushing the Peaches and Cream Complexion; Learn the popular Newborn Skin Layering techniques; Complete your work with Accents and Body Art AND includes Soft Body Doll Kit Patterns from the PatternsByJeannine™ line; sure to create a cuddling collectible doll. Bring to life your own Custom Reborn Baby.
Isn't it time for A Precious Heirloom Baby of your very own?

Disc Cover Insert Front

NOW MOVIES ON CD…

Excellence in Reborn Artistry™ presents to you… MOVIEs ON CD
Watch and Learn Basic Hair Hand Rooting Techniques; Or how to create a Peaches and Cream Complexion or a Realistic looking Newborn with a skin tone so real, it looks like a real life baby…

In our Hair Rooting movie… Jeannine takes you through an introduction to Hair Rooting Tools, Mohair Types, Basic Doll Vinyl Effects, and Felting Needle Basics while demonstrating several Techniques for creating your realistic baby Collectible & Heirloom "One of a Kind" Doll. This Instructional movie for the beginning artist or Reborn hobbyist will show you in detail how to create the cute little curly Q hair and more…

Disc Cover Insert Front

In our Learn to Paint movies… you will learn the perfection of the Peaches and Creams Complexion, along with Newborn Skin Layering Techniques! Our featured Secrist dolls in this movie are Zoe, Ming & Starling; PLUS in addition Taffy - a wonderful example of medium skin tone newborn layering techniques. We also touch on Veining, Facial Accents and Body Art options.
Wonderful techniques that can also be used for acrylics, oils, gouache and more…

Disc Cover Insert Front

Find all our Books, eBooks, and Movies on CD at www.lulu.com/jeannine

www.ingramcontent.com/pod-product-compliance
Lightning Source LLC
Chambersburg PA
CBHW051050180526
45172CB00002B/586